A COLLAGE of CUSTOMS

mark podwal

Hebrew Union College Press on behalf of the Skirball Museum,
the Hebrew Union College – Jewish Institute of Religion, Cincinnati, Ohio

HEBREW UNION COLLEGE PRESS
© 2020 Mark Podwal
Cover design and typesetting by Paul Neff Design LLC
Typeset in Cronos Pro
Printed in the United States of America

Library of Congress Cataloging-in-Publication Data

Names: Podwal, Mark H., 1945- author.

Title: A collage of customs / Mark Podwal.

Description: Cincinnati : Hebrew Union College Press, 2021. | Includes
bibliographical references. | Summary: "Modernized illustrations based
 upon 16th-century mingahim books (books of Jewish customs), with an
 introduction, and descriptions of each image"-- Provided by publisher.

Identifiers: LCCN 2020046249 | ISBN 9780878205097 (paperback) | ISBN
9780878205103 (adobe pdf)
Subjects: LCSH: Fasts and feasts--Judaism--Exhibitions. | Skirball
Museum--Exhibitions.
Classification: LCC BM690 .P638 2021 DDC 296.4--dc23
LC record available at https://lccn.loc.gov/2020046249

iv

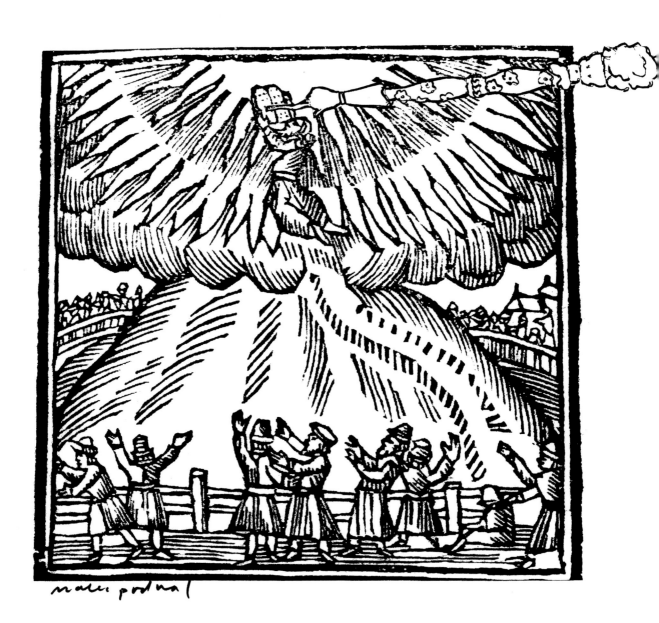

mater podnal

When Mark Podwal began his conversations with HUC Press about a small book that would consist of twenty-six collages based on woodcuts in a sixteenth-century *Sefer Minhagim (Book of Customs)*, he also proposed an exhibition of the artwork at the Cincinnati Skirball Museum. It took me no time at all to reply with a resounding "Yes!" I was similarly approached by the artist in 2016 for permission to draw ritual objects from the B'nai B'rith Klutznick National Jewish Museum's collection, which had been absorbed by the Skirball Museum in 2015. That collaboration led to the exhibition *"Drawing" from the B'nai B'rith Klutznick Collection* and to a lasting relationship with Mark Podwal and his art, in which he brings humor and whimsy to religious objects and texts while at the same time delivering profound and nuanced commentary on Jewish customs and history.

The Skirball Museum is delighted to display archival prints of the twenty-six collages represented in this volume in our recently renovated exhibition gallery, where state-of-the-art lighting will enable our patrons to enjoy these imaginative and inventive interpretations of the sixteenth-century woodcuts. We are fortunate to be able to include in the exhibition examples of a number of editions of the *Sefer Minhagim* from the Klau Library on the Cincinnati campus of Hebrew Union College-Jewish Institute of Religion, including the 1593 Venice edition that was the inspiration for *A Collage of Customs*.

Museums are tasked with making art of the past accessible and approachable to modern-day audiences. In collaboration with Mark Podwal we have been able to exceed this aim again and again. I have no doubt that visitors to this exhibition and readers of this volume will see the historic images in a new light as they experience them in the context of Mark Podwal's delightful and insightful interpretations.

Abby S. Schwartz
Director, Cincinnati Skirball Museum

TABLE OF CONTENTS

If you come to a town, follow its customs.

For when Moses went up to Heaven

he refrained from food for forty days and

forty nights, and when the angels came 1

down to visit Abraham they partook

of his meal, each one submitting to the

custom of the place.

Preoccupied with Jewish history and fascinated by Judaism's customs, legends, and mystical tradition, I've tried to imaginatively interpret and faithfully transmit my heritage through pictorial narratives. Much of my art includes visual metaphors adapted from Jewish symbols and iconography. Among the most frequently reproduced artworks in the lexicon of Jewish imagery are the woodcut illustrations from the *Sifrei Minhagim* (Yiddish: *Minhogimbikher*, books of Jewish customs) produced from the sixteenth through eighteenth centuries. These images portray observances and rituals of the Jewish year and life cycle with figures in distinctive Ashkenazi (Western European) dress.[1] Even customs books by Sephardic Jews (who traced their heritage to Spain) reproduced the same Ashkenazi iconography.[2] In modern times these illustrations have become somewhat familiar as they have been published countless times, not only accompanying religious texts, but also in encyclopedias, on book jackets, and even on greeting cards. To update and introduce new layers of meaning to these centuries-old images, I've created a series of twenty-six collages. A giant electric light bulb, a microwave, and a hairdryer are among the modern-day objects juxtaposed with the sixteenth-century depictions of Jewish customs. A comically large *hamantasch* (a triangular cookie eaten on the festival of Purim) collaged as Amalek's hat pictures the ancient enemy of the Jewish people as the ancestor of the defeated villain of the biblical Book of Esther. A thought bubble inserted into a wedding illustration expresses the tradition that even at times of joy Jews still recall the destruction of the Temple in Jerusalem.

The *Sifrei Minhagim* were among the most popular Jewish books in sixteenth to nineteenth-century Europe. In concise and easily understandable language, the text explained how to observe Jewish rituals and customs in the proper fashion. According to authoritative rabbinic sources, "Everything depends on local custom."[3] Furthermore, these sources assign such importance to custom that they affirm it can sometimes cancel or even replace prescribed Jewish law. Whereas certain customs are based on *halakhah* (Jewish law), many other customs were shaped by the folklore, traditions, and superstitions of the places Jews lived. *Minhagim* books can describe customs unique to a certain region only regarding one practice, or treat a wide range of customs with the purpose of presenting and perpetuating continuity in practice. The *minhagim* manual was especially useful in small communities, which often had no rabbi or were far from centers of study. Without the opportunity to consult someone knowledgeable as to a rule or custom, custom books, although not a replacement for an authority, provided clarification. For those who might not recall the rituals studied in their youth, custom books could serve as a reminder.[4]

The first *minhagim* book to survive is the *Sefer ha-Ḥillukim bein Mizraḥ ve-Ereẓ Yisrael* (*Variations in Customs between the People of the East and of Israel*), likely compiled in eighth-century-CE Palestine. The "People of the East" referred to the Babylonian Jews who preserved the customs of their land of origin. Another work, *Ḥilluf Minhagim*, from the same period and of which not even a fragment has survived, described the differences in customs between the Babylonian Talmudic Academies of Pumbedita and Sura.[5]

During the thirteenth and fourteenth centuries, scholars attempted to verify the origins of various customs and establish a uniformity of practices. Among the first European customs books is the *Sefer ha-Minhagot* of Asher ben Saul of Lunel (late 12th and early 13th century), which describes a wide variety of Jewish practices of southern France. Asher sought to support observance by providing Talmudic, Midrashic, and Babylonian geonic sources. During his travels, Abraham ben Nathan Ha-Yarhi, a Provençal rabbi (1155–1215), noted that "they (the Jews) varied in their religious practices and were divided into seventy languages."[6] In his book *Manhig Olam*, composed in Toledo in 1204 and known popularly as *Sefer ha-Manhig*, Abraham collected customs he personally observed regarding prayer and synagogue practices in medieval France, Germany, Spain, and England. He relates that in France it was the custom on Purim for Jewish children to bring their Christian nurses to the synagogue courtyard where their parents presented them with gifts. As this custom neglected the Jewish poor, Abraham adds that it was strongly criticized and that Rashi is said to have denounced it. Among the most influential collections of Ashkenazi customs and practices is Rabbi Jacob Halevi Moelin's (Maharil, 1360–1427) *Sefer ha-Maharil*, or *Minhagim*, compiled by his pupil R. Eleazar ben Jacob from the discourses he heard from his teacher. *Sefer ha-Maharil* presents comprehensive descriptions of synagogue and home religious observances of the German Jews, and views unfavorably any variations.[7]

The author of a Hebrew manuscript of Jewish customs, later to be printed in an extraordinarily popular illustrated Yiddish edition, was the Austrian Rabbi Isaac Tyrnau (late 14th to early 15th century). Recognizing that a compendium of customs was especially vital in perilous times when ignorance threatened to destroy Jewish society, Tyrnau collected Ashkenazi customs from Bohemia, Moravia, Germany, and Poland in the wake of the Black Death (1348–1350), when hundreds of Jewish communities, falsely accused of causing the pestilence, were annihilated across Europe. "Scholars became so few," writes Tyrnau, "I saw localities where there were no more than two or three persons with a real knowledge of local custom, let alone those of another town."[8] In the introduction to his manuscript, Tyrnau mentions that it was not intended for the literate but for all the Jews, in order to "straighten out, correct and put well in order the practices of the entire year, so that they will be perfectly known by every person, and more than that, in simple language."[9]

For around one hundred and fifty years Tyrnau's Hebrew text, *Minhagim le-Kol ha-Shanah*, circulated in manuscript form until it first appeared in print in 1566. Although reprinted numerous times, often as an appendix to a prayer book, for the guide to be useful to a large lay audience a Yiddish translation was needed. In 1590, a Yiddish translation by Rabbi Simon Levi ben Judah Guenzburg was printed in Venice. For the following three hundred years, Yiddish would be the language of most editions. Regrettably, Tyrnau's name is frequently omitted from the work with only Guenzburg's name credited. According to the historian Jean Baumgarten, "Although Isaac Tyrnau's book seems to be one of the most important sources for the Yiddish version…Guenzburg used a large spectrum of sources and was more than a simple translator of rabbinic sources into Old Yiddish…and adds many interpretations and personal comments on practices, ritual, and religious life."[10] Along with the large group of Yiddish speakers residing in Italy, the book's primary readers were most likely the Jews of Central and Eastern Europe.

In 1593, woodcuts illustrating the second Yiddish edition significantly contributed to the book's immense popularity and made it the prototype for later printings.[11] Twenty-six squarish woodcuts depict Jewish customs and contemporary costume; twelve smaller horizontal woodcuts denote the month's zodiac and chores of the agricultural year. Five of the customs' images reappear several times. In addition, there is a Hebrew calendar for the following seventy years. The 1593 Yiddish edition's title page proclaims, "Much nicer than previous versions. Everyone will enjoy reading it! Laws explained well, so you will learn how to live like a good person."[12] In her study of the images in five illustrated Yiddish books from sixteenth-century Italy, art historian Diane Wolfthal writes that Yiddish books were not only illustrated for educational purposes or "as cues to the reader searching for a particular passage of the text"[13] but because "some adult Jews enjoyed looking at them."[14] Recognizing the visual pleasure derived from looking at pictures, Venetian Rabbi Leon Modena (1571–1648) noted that illustrations "entice the bodily eyes."[15] Prior to the 1593 *Sefer Minhagim*, the earliest surviving illustrated Yiddish compilation of Jewish customs is an Italian manuscript from around 1503; its text is mostly copied from Isaac Tyrnau. Both the calligraphy and images seem to be by one individual. Moreover, the manuscript's over ninety amateurish line drawings show a firsthand knowledge of Jewish holidays, life cycle occasions, and Jewish history, and notably depict a large number of customs practiced by women. Sometime after 1662, the book came into the possession of Cardinal Richelieu and is now in the collection of the Bibliothèque nationale de France.[16]

From the 1593 *Sefer Minhagim* to the 1774 Amsterdam edition, the volumes' woodcuts were routinely unimaginatively copied. Infrequent revisions included adding black and white Dutch floor tiles and varying windows. Wolfthal observes that the professional artists illustrating Jewish books were mostly Christians with minimal education who could thus contribute little intellectually, and who, according to Sandra Hindman, were merely "technicians, plying a craft."[17] Yet at times, images were corrected.

The 1593 illustration of lighting the Hanukkah menorah likely reveals an unawareness of the Talmudic dictum that "It is forbidden to use a seven-branched menorah outside the Temple."[18] Adhering to the dictum, a later Amsterdam edition adds an eighth candlestick.[19] Although Judaism prohibits the portrayal of God in any kind of human or concrete form, the 1593 Venice Shavuot woodcut pictures God's hand giving Moses the Ten Commandments. A 1723 Amsterdam Shavuot woodcut omits any visual representation of God, and sets the revelation at Sinai near a Dutch village.

Only the 1601 Venice *minhagim* book has distinctly different images, which are far more artful than the 1593 edition's, and present the characters in Italian rather than German style clothing. Wolfthal notes that this new set of attractive images "brought Titian's style into Jewish homes."[20] Believing that a proper understanding of Jesus required a proper understanding of Jewish practices, Johannes Leusden (1624–1699), a Dutch Calvinist theologian and one of the most prominent Bible experts of his time, included thirteen Amsterdam *Sefer Minhagim* woodcuts in his *Philogus Hebraeo-Mixtus (A Philology of Hebrew and Other Languages)*, (Utrecht, 1663). The book's popularity resulted in a second edition in 1682 with Dutch artist Johan van den Avele's eight new engravings illustrating Jewish customs.

The *Sefer Minhagim* woodcuts were designed to illustrate a text, presumably not to live a life of their own. Yet, in modernity, those images are often set free from the pages of *minhagim* literature or any textual reference. The Israel Museum sells reproductions of the woodcuts on decorative ceramic tiles. Framed prints of the images are marketed online. Reproduced innumerable times with minimal variations for over four centuries, these classic woodcuts seemed to me to call out for a "makeover." And so, with this series of collages, centuries-old familiar *minhagim* illustrations have been reimagined.

Mark Podwal

1 On the history of these illustrations see Diane Wolfthal, "Imagining the Self: Representations of Jewish Ritual in Yiddish Books of Customs," in *Imagining the Self, Imagining the Other: Visual Representation and Jewish-Christian Dynamics in the Middle Ages and Early Modern Period*, ed. Eva Frojmovic (Leiden: Brill, 2002), 189–211.

2 On the movement of these images across time and place see Jean Baumgarten, "'Sefer Haminhagim' (Venice, 1593) and its Dissemination in the Ashkenazi World," in *Minhagim: Custom and Practice in Jewish Life*, ed. Jean Baumgarten, Naomi Feuchtwanger-Sarig, Joseph Isaac Lifshitz and Simha Goldin (Berlin: De Gruyter, 2020), 83–98.

3 See, for example, the following sources from the Mishnah (Bava Metzi'a 7:1, 9:1; Bava Batra 1:1, 10:1; m. Sukkah 3:11; Pesachim 4:1) and from the Babylonian Talmud (Pesachim 50a, 51b, 119b; Sukkah 38a; Megillah 21b; b. Bava Metzi'a 86b).

4 On the popularity of these works and a basic overview of their contents and purpose see Scott-Martin Kosofsky, "A Discovery: The Venice Minhogimbukh," *Judaism* 53:3–4 (2004): 207–19.

5 On the various versions of the *Sefer Minhagim* see the concise discussion in Israel Ta-Shma, et al. under "Minhagim Books." *Encyclopaedia Judaica*, ed. Michael Berenbaum and Fred Skolnik, 2nd ed., vol. 14, Macmillan Reference USA, 2007, pp. 278–80.

6 "Abraham ben Nathan Ha-Yarhi." *Encyclopaedia Judaica*, ed. Michael Berenbaum and Fred Skolnik, 2nd ed., vol. 1, Macmillan Reference USA, 2007, p. 309.

7 Herman Pollack, "An Historical Explanation of the Origin and Development of Jewish Books of Customs ("Sifre Minhagim"): 1100–1300." *Jewish Social Studies* 49, no. 3/4 (1987): 195–216.

8 Shmuel Ashkenazi, "Tyrnau, Isaac." *Encyclopaedia Judaica*, ed. Michael Berenbaum and Fred Skolnik, 2nd ed., vol. 20, Macmillan Reference USA, 2007, p. 220.

9 Jean Baumgarten, "Prayer, Ritual and Practice in Ashkenazic Jewish Society: The Tradition of Yiddish Custom Books in the Fifteenth to Eighteenth Centuries," *Studia Rosenthaliana* 36 (2002–2003): 128.

10 Jean Baumgarten, "Prayer, Ritual and Practice in Ashkenazic Jewish Society," 138.

11 Jean Baumgarten, "Prayer, Ritual and Practice in Ashkenazic Jewish Society," 137.

12 Scott-Martin Kosofsky, *The Book of Customs* (New York: HarperOne, 2004), xiv.

13 Diane Wolfthal, *Picturing Yiddish: Gender, Identity, and Memory in the Illustrated Yiddish Books of Renaissance Italy* (Leiden: Brill, 2004), 204.

14 Diane Wolfthal, *Picturing Yiddish*, 206.

15 Diane Wolfthal, *Picturing Yiddish*, 206.

16 Diane Wolfthal, *Picturing Yiddish*, 10–13.

17 Diane Wolfthal, *Picturing Yiddish*, 150.

18 Babylonian Talmud Menachot 28b.

19 Diane Wolfthal, *Picturing Yiddish*, 96.

20 Diane Wolfthal, *Picturing Yiddish*, 206.

Rosh Hashanah

The shofar (ram's horn) is blown on Rosh Hashanah (the New Year) to fulfill the Torah's commandment, "On the first day of the seventh month, you shall observe complete rest, a sacred occasion commemorated with loud blasts" (Leviticus 23:24. Cf. Numbers 29:1). According to custom, four sets of notes are sounded: *tekiah*, a long blast; *shevarim*, three short blasts; *teruah*, nine staccato blasts; and *tekiah gedolah*, a very long blast. Although the holiday is also known as *Yom Teruah*, the day of the sounding of the shofar, the actual mitzvah is to listen to the shofar's sounds, and the custom is to stand whenever the shofar is sounded. According to rabbinic sources, in the Temple in Jerusalem the shofar was sometimes blown together with trumpets; the shofar would be positioned in the center with a trumpet on either side. The Torah does not specify why a shofar is blown on Rosh Hashanah. The ninth-century sage Saadia Gaon proposed ten reasons for this commandment. Among these explanations is that the shofar evokes God's revelation at Sinai, an event accompanied by shofar blasts (Exodus 19:12–13). While it is forbidden to embellish the shofar with

painting, old shofars have been found with biblical inscriptions. Traditionally, the use of a cow's horn is forbidden because it reminds God of the sin of the Golden Calf. The custom of placing one foot on a stool while blowing the shofar was common in Germany in the Middle Ages. The rationale for this practice is unclear but it has been suggested that it represented the wish to project the shofar's sound as high as possible in order to reach heaven. A midrash states that God told Abraham, "Thy children will sin before Me in time to come, and I will sit in judgment before them on the New Year's Day. If they desire that I should grant them pardon, they shall blow the ram's horn on that day, and I, mindful of the ram that was substituted for Isaac as a sacrifice, will forgive them for their sins." There is also a widespread custom not to sleep during the day on Rosh Hashanah. Rabbinic sources teach, "if one sleeps at the year's beginning, his good fortune will also sleep." Moreover, because sleep has been described "as a taste of death," on the New Year one should avoid sleeping and set the course of the year to come through prayer, Torah study, and good deeds.

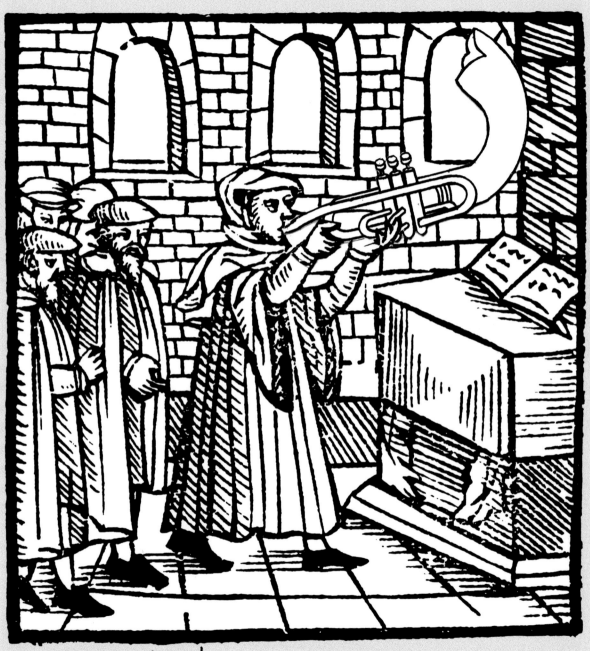

mace podual

Shabbat Shuvah

In the Hebrew calendar, certain Shabbats are given a special name as well as supplemental liturgy and customs. Shabbat Shuvah (The Sabbath of Return) occurs between Rosh Hashanah and Yom Kippur during the Ten Days of Repentance. Those ten days are regarded as one's last chance, through one's actions, to be inscribed for the coming year in the *Book of Life*. The word *"shuvah"* (return) is derived from the first word of this Shabbat's special haftarah (reading from Scripture), which begins with Hosea 14:2 "Return, O Israel, unto the Lord." In addition to verses from Hosea, on this Shabbat Ashkenazi Jews also read verses from Micah and Joel. The passage from Micah includes a scriptural basis for the Rosh Hashanah custom of *tashlikh*, "He will hurl our sins into the depths of the sea" (Micah 7:19). *Tashlikh*, meaning, "you will cast away," is a ritual in which participants symbolically cast off their sins by tossing breadcrumbs into a body of water. A reference to the shofar and the High Holidays is included in the reading from Joel, "Blow a horn in Zion, Solemnize a fast, Proclaim a solemn assembly!" (Joel 2:15). The verses from Joel are omitted by Sephardi Jews.

Traditionally, rabbis only gave sermons on two Shabbats, the one preceding Passover, called Shabbat HaGadol, the Great Sabbath, and Shabbat Shuvah. It is the custom on Shabbat Shuvah for rabbis to deliver an admonitory sermon focusing on repentance, prayer, and charity, which, according to the High Holidays prayer, *Un'taneh tokef* (We shall ascribe holiness to this day), can ensure a positive fate. A parable from the early rabbis often cited by preachers tells of a prince who was a hundred days' journey from his father and though wanting to return did not have the strength. His father sent word that his son should go as far as his strength allows and he will come the rest of the way to meet him. And likewise God says to Israel, "Return to Me, and I will return to you." Sermons given on Shabbat Shuvah often express the frustration rabbis encounter as they attempt to motivate their congregants to change their ways. Prague's Chief Rabbi Ezekiel Landau (1713–1793) confessed, "My words have not been successful, nor borne fruit, for you have not accepted my ethical instruction. Worse, the more I continue to chastise, the more the dissoluteness grows."

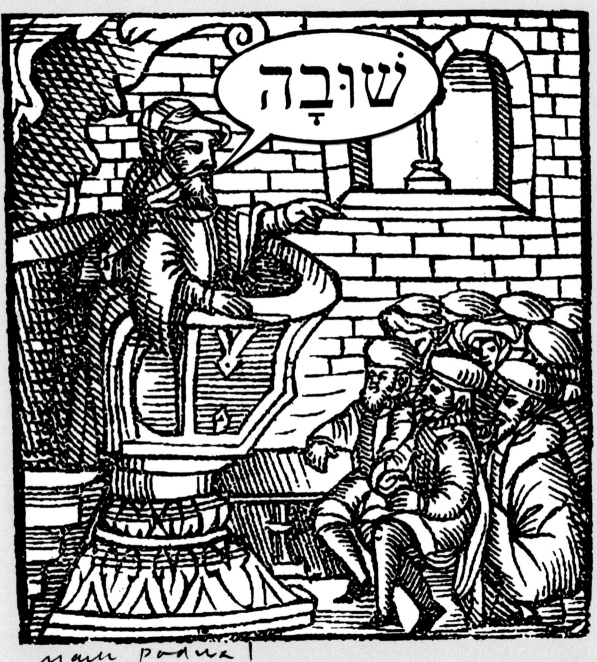

Ushpizin

According to rabbinic tradition, Jews build a sukkah (booth) on the festival of Sukkot to recall the Israelite's fragile dwellings during their forty years of wanderings after the Exodus from Egypt (Leviticus 23:33–43). However, the customary interpretation of a sukkah is anachronistic, as tents would have been more likely than booths in the wilderness. Perhaps the Israelites initially celebrated the festival in tents, which were later replaced by the sukkah, symbolic of the temporary shelters used by farmers during the last days of the fall harvest. Or perhaps the Israelites assimilated a Canaanite custom of observing a seven-day festival by constructing booths, which in Canaanite practice served as pavilions erected for various deities. In a Talmudic dispute discussing the meaning of the word "booths," Rabbi Eliezer takes the word literally while Rabbi Akiva understands it figuratively as "clouds of God's presence." These "Clouds of Glory" protected the Israelites from the hot sands, the burning sun, scorpions and snakes, and even the assaults of their enemies. The ritual celebration

of Jewish holidays usually begins with reciting the blessing over wine, the Kiddush (sanctification). On Sukkot, however, on entering the sukkah one begins by inviting the *ushpizin* (Aramaic for "guests")— Abraham, Isaac, Jacob, Joseph, Moses, Aaron, and David. Whereas the *ushpizin* are first mentioned in the *Zohar* (late thirteenth century), the custom of actually inviting them as guests is attributed to Isaac Luria, the sixteenth-century kabbalist (mystic) of Safed. According to tradition, these seven guests will accompany the Messiah at the time of the final Redemption. On each of the seven days of Sukkot one of the seven *ushpizin* comes to visit. Customarily, the *ushpizin* are welcomed into the sukkah in the order in which they lived. A more recent custom also invites seven female *ushpizot*: Sarah, Rachel, Rebecca, Leah, Miriam, Abigail, and Esther. Whereas pictures of the *ushpizin* and *ushpizot* often decorate the sukkah, some cover the interior walls with white sheeting to recall the "Clouds of Glory" that surrounded the Children of Israel during their desert wanderings.

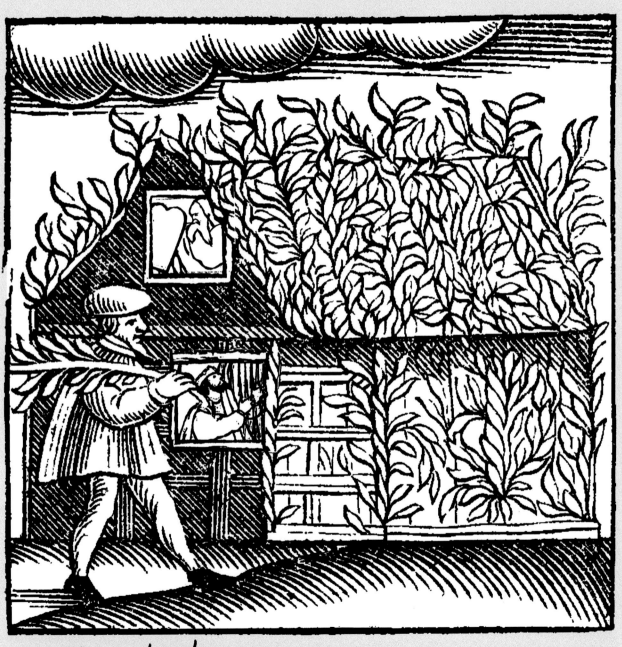

mark podwal

Sukkot

The Torah commands no less than three times to rejoice and be happy on Sukkot, the celebration of the fall harvest (Leviticus 23:39–40; Deuteronomy 16:14–16). Symbols of the harvest, the *lulav* (palm branch, myrtle, and willows) and *etrog* (citron), are blessed and waved and a sukkah (booth) is built and decorated. The *lulav* and *etrog* must be held in the direction in which they grew. For the *etrog*, this means that the stem end should be on the bottom and the blossom end on top. To recite

the blessing over the *lulav* and *etrog*, the *lulav* is held in one hand and the *etrog* in the other. Right-handed users hold the *lulav* in the right hand and the *etrog* in the left. The customs for those who are left-handed differ for Ashkenazim and Sephardim. According to the Ashkenazi custom, the *lulav* is held in the left hand, while Sephardi custom designates the right hand. Conforming to Sephardi custom, the blessing is said while holding only the *lulav* and the *etrog* is picked up once the blessing is completed. In Ashkenazi practice, before

the blessing is said the *etrog* is held upside-down opposite the direction in which it grows. The reason for these two customs is that the blessing must precede the performance of the mitzvah. Should all the species be held in the direction in which they grew, the mitzvah would be fulfilled before the blessing is recited. After reciting the blessing, the *etrog* is picked up or turned right side up and the two hands are brought together so that the *etrog* touches the *lulav*. The four species are then held up and shaken three times toward each of the four directions, as well as up and down, to signify God's omnipresence. To protect the *etrog* during Sukkot, it is the custom to wrap it in silky flax fibers and store it in an ornate box. After the festival, an Ashkenazi custom was to make a syrupy jam from the etrog, known as *eingemacht* (preserve). The preserve was saved until Tu B'Shevat (the New Year for Trees) when it was eaten with a spoon while sipping hot tea, with prayers that the worshiper will merit a beautiful *etrog* the following Sukkot.

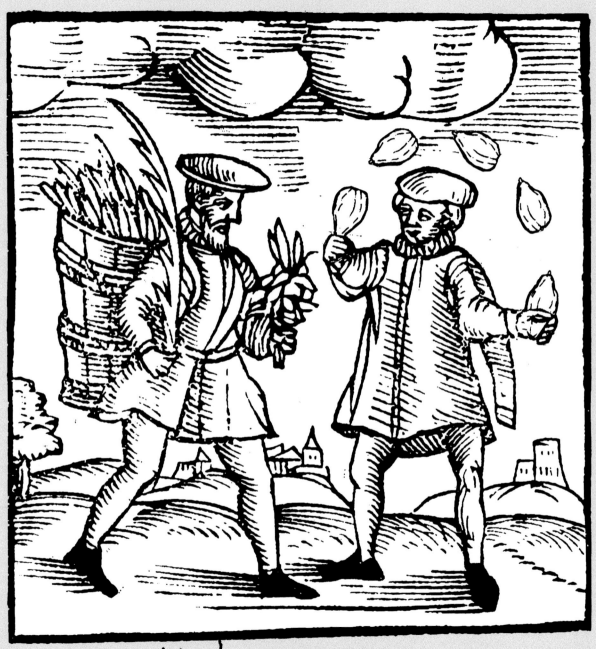

masopust

Hoshana Rabbah

Hoshana Rabbah is the seventh day of the festival of Sukkot. *Hoshana* is Hebrew for "please save (us)" and refers to a series of seven liturgical poems recited on the day. Collectively these make for a Hoshana Rabbah, a great petition for salvation. Some believe that on the night of Hoshana Rabbah a person's fate for the year ahead, already decided by Yom Kippur, is irrevocably written in the *Book of Life*. But according to Kabbalah (Jewish mysticism), there is no verdict that cannot be changed.

Thus, a traditional practice on Hoshana Rabbah eve is to study Torah the entire night to alter— if necessary—one's decree for the coming year. Among medieval Jews it was a popular custom to go out into the moonlight to see whether their shadows were intact. If a shadow lacked a head it was a sign that the judgment determined upon the shadow would be visited on the person, who would die during the new year. If a right hand was missing a son would die. If a left hand was missing a daughter would die. The shadow seen in the moonlight was believed not to be a regular shadow, but a shadow called *bevoah bivevoah*—a secondary shadow cast by the real shadow. The earliest Jewish mention of this practice was by the Talmudist Eleazar of Worms (c.1176–1238). The basis for the custom is taken from Numbers 14:9, "their shadow is removed from them." (The Hebrew word for shadow – *tsellem* – is a metaphor for protection.) A related belief was that the reflection in a basin of water of a man doomed to die would show him with his eyes and mouth closed, even though he had them wide open. Although Jews would generally practice the ritual of the shadow on the night of Hoshana Rabbah, some observed it on Yom Kippur. On Hoshana Rabbah morning, following Musaf, the congregation marches around the synagogue seven times, after which is practiced the holiday's oldest recorded *minhag*, the beating of the *aravah* (willow branch). The willow branch is beaten against the floor five times. The origin of this custom remains obscure.

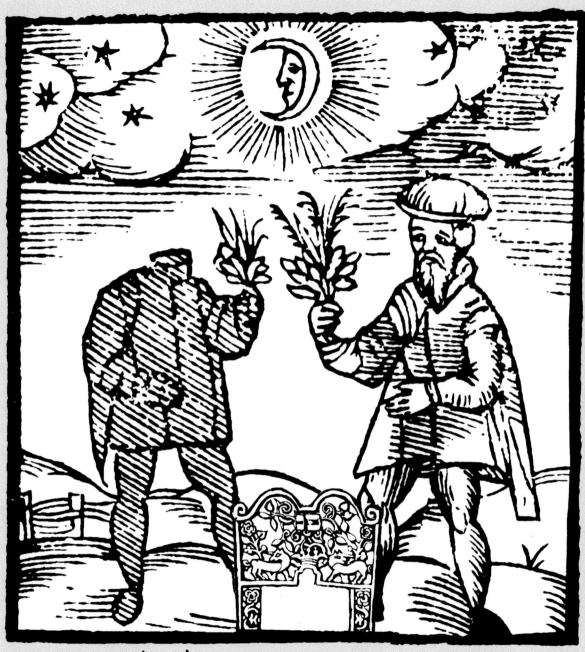

marek padwal

15

Simchat Torah

Simchat Torah, "The 'Rejoicing of the Torah," is the day following the feast of Sukkot when the annual cycle of the Torah reading is completed and begins again. The holiday, not mentioned in the Torah or the Talmud, came into being in the Middle Ages, when weekly readings of the Torah on an annual cycle became common practice. During the evening service, all the Torah scrolls are removed from the Torah ark and congregants carrying the scrolls circle the synagogue seven times. A custom which originated in sixteenth-century Europe had children waving paper flags join the procession. In Eastern Europe children would march in a procession from house to house carrying flags. The Torah reading on Simchat Torah morning is customarily performed under the *chuppah* (canopy) of a *tallit* (prayer shawl) to symbolize the wedding of Israel and the Law. Immediately after the last words of the final Torah chapter have been chanted, the chanting of the first chapter begins. The person called to read the concluding Torah portion is called *Chatan Torah* (Bridegroom of the Torah) or *Kalat Torah* (Bride of

the Torah) while the person who follows is called *Chatan* or *Kalat Bereshit* (the Bridegroom or Bride of the Beginning of Creation—the first narrative in the Torah). According to tradition, this custom's purpose is to ward off the goading of Satan who otherwise may allege, "Lord, behold Thy favorite children. They finish the study of the Torah and have no desire to continue." Formerly, those honored with completing the Torah and starting it anew would be escorted with lit candles and torches, just as a wedding entourage carried lit candles. Another custom was to affix to the top of children's flags an apple with a hole carved out for a lighted candle to symbolize the light of the Torah. Nowadays, Jews no longer march with candles and torches on Simchat Torah. Over the years, many rabbis decried this custom, presumably because of fear of conflagration, especially when children carried the candles. The apple on the flag may have evolved from the Simchat Torah tradition that apples were thrown with other treats for the children to gather because the Lord's "commandments are sweeter than honey" (Psalms 119:103).

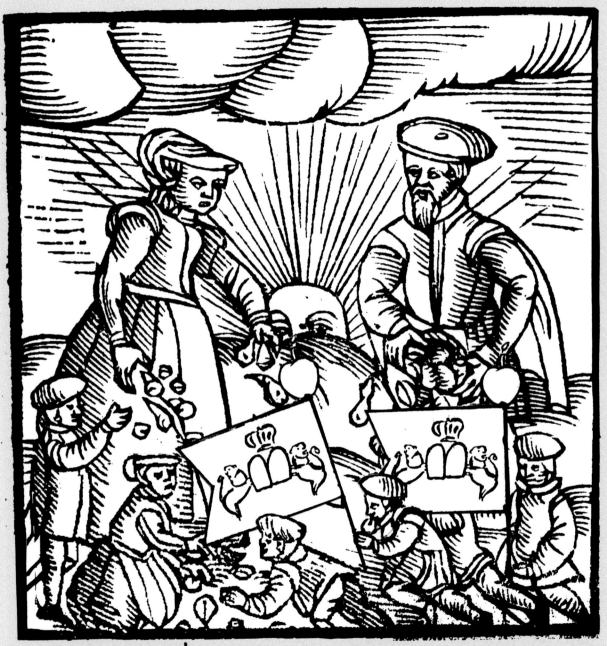

mau. prana/

Hanukkah

The eight-day-festival of Hanukkah is celebrated with the kindling of a *hanukkiah* (candelabrum). The Talmud recalls that when the Maccabees rededicated the defiled Jerusalem Temple a cruse of consecrated oil, enough to light the Temple menorah (candelabrum) for one day, miraculously lasted eight days—the time needed to prepare new oil. Earlier sources such as the Books of Maccabees do not mention the miracle of lights but highlight the military victory of the Jews over their Seleucid oppressors in 164 BCE. Neither does the ancient historian Josephus

(37–c. 100) mention the miracle in his account of the "Festival of Lights." The Talmudic preference for the miracle story may have resulted from the rabbinic consideration that under Roman domination it would have been unwise to celebrate Hanukkah as a commemoration of a successful Jewish rebellion. The sixteenth-century Maharal of Prague, Rabbi Judah Loew, explains the rabbinic emphasis on the miracle of the oil as indicating that the entire story was a miracle, the war as well. Required for proper fulfillment of the mitzvah (commandment) of kindling

the Hanukkah lights are *pirsumei nissa* (publicizing the Hanukkah miracle) and *la-shem mitzvah* (using an item uniquely for the ritual). From ancient times, publicizing the miracle customarily called for hanging the Hanukkah lights outside the house on the left doorpost opposite the mezuzah. Nowadays, the lights are traditionally placed in a window. Hanukkah lights uniquely celebrate the miracle and are not used for illumination. In Talmudic times, Hanukkah lamps were of clay or stone with eight wick spouts. During the Middle Ages, an ornate triangular metal Hanukkah oil lamp would be affixed to a wall. After the Temples were destroyed, a tradition arose not to duplicate anything modeled on the objects of the Temple. Nevertheless, from the sixteenth century on, nine-branched Hanukkah lamps resembling the seven-branched Temple menorah were lit in synagogues and later in homes. Fried foods such as potato pancakes (*latkes* in Yiddish) and doughnuts (*sufganiyot* in Hebrew) are traditional for Hanukkah. Cooked in oil they are reminders of the miracle.

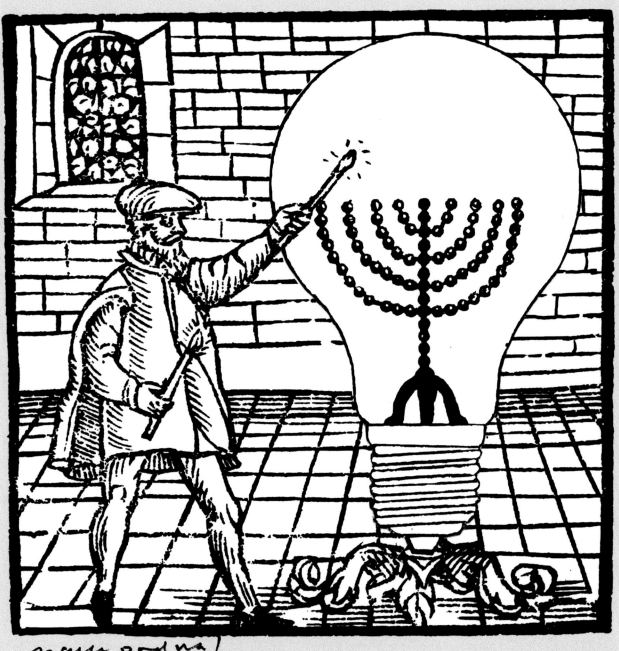

Tu B'Shevat

Tu B'Shevat is a transliteration of the Hebrew date, "the fifteenth of the month of Shevat." Traditionally named the "New Year of the Trees," Tu B'Shevat is one of four Jewish new years specified in the Mishnah. The holiday originated in the Talmud for the purpose of calculating the age of fruit trees to be tithed to the Temple in Jerusalem. Due to the festive nature of the day, Jewish Law forbids fasting and eulogies, and all penitential prayers are omitted. A tradition arose among Sephardic Jews to stay up all night to study Torah, Talmud, and *Zohar*. On Tu B'Shevat, it is the custom to increase the types of fruits eaten, especially fruits mentioned in the Torah associated with the Holy Land: grapes, figs, pomegranates, olives, and dates. A kabbalistic Tu B'Shevat seder (ritual meal) was introduced in Safed during the sixteenth century in which fifteen varieties of fruit were eaten as a spiritual repair for the sin of Adam and Eve who ate the forbidden fruit in the Garden of Eden. The text for the seder is called *Peri Ez Hadar*, "Fruit of the Goodly Tree." Jews also try on Tu B'Shevat to eat at least one

fruit not tasted during the year. Hassidic Jews pray for a perfect *etrog* for Sukkot, and there is a tradition to eat an *etrog*, either as preserves or sugared slices. Moreover, Jews plant trees on this day, or collect money towards planting trees in Israel. For hundreds of years, rabbis have taught how important trees are. According to the Midrash, "If not for the trees, human life could not exist." Rabbi Yochanan ben Zakkai used to say, "If you have a sapling in your hand and you are told that the Messiah has come, first plant the sapling and then go and welcome the Messiah." Legend claims that on Tu B'shevat the trees embrace, kiss, and wish one another a happy new year. Anyone who witnesses this miraculous event will have a wish fulfilled. Tu B'Shevat is a considered a minor festival because there is no mention of the festival in the Torah. However, according to the last Lubavitcher Rebbe, Rabbi Menachem Schneerson (1902–1994), since Tu B'Shevat is a custom, not a commandment, its celebration offers God great delight because its observance is not required.

20

mau prinal

Shabbat Shekalim

Shabbat Shekalim, the "Shabbat of the Shekels," is the first in a series of four special Shabbats that begin before Purim and continue through Passover. Referring to the supplementary Torah reading on each of the special Shabbats, the series is known as the *Arba Parshiot*, the "Four Portions." Shabbat Shekalim is named for the supplementary Torah reading *Ki Tisa* ("when you take," Exodus 30:11–34:35), which describes a census requiring every Israelite man over the age of twenty to contribute half of a shekel to support the construction of the Tabernacle, God's dwelling place in the wilderness. Everyone gave the same amount—"the rich shall not pay more, and the poor shall not pay less than a shekel" (Exodus 30:11–16). An ancient fear that counting people might expose them to supernatural danger underlies the Talmudic dictum not to count the Israelites directly. Instead, when counting was required, objects representing each person were counted. This practice continues in the Jewish custom for determining a minyan (a quorum of ten over the age of thirteen required for Jewish public worship); instead of numbers, ten words of a biblical verse are recited, each word corresponding to one of those counted. Similarly, the medieval rabbinic authority Rashi holds that it is the half-shekels, not the people that are to be counted,

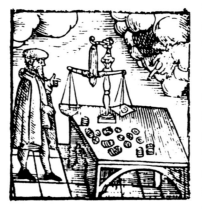

which would explain why all must pay the same amount. A midrash tells that Moses learned what a half-shekel was through God's right hand, for each finger of God's hand served a different purpose. With His index finger God showed Moses a coin made of fire, the weight of which was a half-shekel, and said to him, "Like this shall they give." The tax remained in effect through the time of the First and Second Temples to support communal sacrifices. During that time, the half-shekel was collected during the month of Adar because the fiscal year of the Temple began in the month of Nisan. The haftarah reading on Shabbat Shekalim is from II Kings 12:1–12:17, which recounts the time of Jehoash, King of Judah, when *shekalim* were collected to make repairs on the Temple. The haftarah relates that those charged with distributing the payments were so trusted that they needed not present an accounting of their expenditures. Today, it is a custom to give three coins to charity on Purim as a commemoration of the half-shekel collected in antiquity. Rabbi Moses Isserles (1530–1572) writes that the three coins correspond to the three times *trumah* (a donation) is mentioned in the Torah portion dealing with the half-shekel. Each coin should be half of the standard currency in use in a particular place at a particular time.

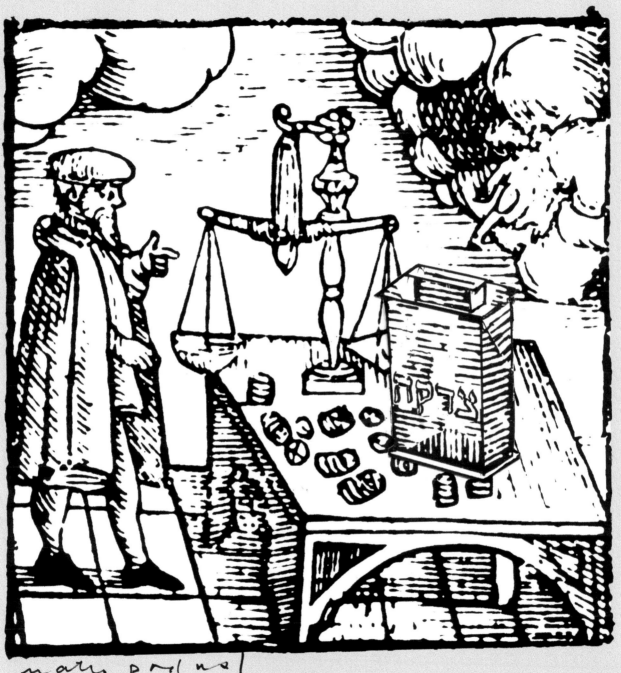

Shabbat Zakhor

Shabbat Zakhor, the "Shabbat of Remembrance," is the Sabbath immediately preceding Purim and is named for the additional Torah reading, Deuteronomy 25:17–19, which begins with the word *zakhor*, Hebrew for "remember." The Torah commands, "Remember what Amalek did to you on your journey out of Egypt, how he attacked you on the way, when you were faint and weary, and struck down all who lagged behind you" (Deuteronomy 25:17–18). The commandment to remember is fulfilled by the yearly public reading of this passage. Some Jewish legal authorities say that the obligation to hear this reading is even greater than the obligation to hear the Scroll of Esther on Purim, since the latter was enacted by the rabbis in antiquity while the Torah requires the reading of *Parashat Zakhor*. The additional command to "blot out the memory of Amalek under heaven" (Exodus 17:14) has given rise to a number of customs. A tradition practiced among *soferim* (scribes) to test a quill for writing a Torah, or parchments for inclusion in a mezuzah, or *tefillin* for use in daily prayer, is, before

commencing, to first write the name of Amalek and then cross it out. A Shabbat Zakhor custom in Amsterdam's Spanish Portuguese Synagogue and several other Sephardi synagogues is to recite a lengthy liturgical poem by Yehudah HaLevi (1075–1141), "Who is like you? There is none like you!" praising God for the miracles of the Purim story. The haftarah read on Shabbat Zakhor is from the Book of Samuel, and recounts the story of the Prophet Samuel's instructions—directly from God—to King Saul to wipe out Amalek, "So says the Lord, 'I remember that which Amalek did to Israel…Now go and smite Amalek, and utterly destroy all that they have, and do not have pity on them'" (1 Samuel 15:2–3). However, King Saul disobeyed and spared Agag, the Amalekite king. A midrash relates that although the prophet Samuel killed Agag, before Agag died he fathered a child from whom was descended Haman, Purim's villain. According to the medieval authority Rashi, *Zakhor* is read on the Shabbat before Purim because of this link between the destruction of Amalek and elimination of his wicked descendant, Haman.

Purim

The medieval philosopher and codifier of Jewish law Maimonides teaches, "The reading of the *Megillat* (Scroll of) *Esther* supersedes all other commandments." The *Megillat Esther* tells the story of the deliverance of the Jews in ancient Persia from the villain Haman's plot "to destroy, kill and annihilate all the Jews, young and old, infants and women, in a single day" (Esther 3:13). On Purim the *Megillah* is read from a parchment scroll that is unrolled, entirely spread out, and folded one column over another so that it is read like a letter. According to Jewish law, it is the obligation of each Jew to listen carefully to every word. During the reading, the custom is to make loud noises to drown out Haman's name. Other Purim customs include wearing masks and costumes, eating triangular pastries called *hamantaschen*—a shape reminiscent of Haman's hat—and performing *Purim-shpiels*, humorous adaptations of the Purim story. Commandments to be observed on Purim include exchanging gifts of food (*mishloach manot*), donating charity to the poor (*mattanot la-evyonim*), and eating a celebratory meal. The Talmud says that one is obliged on Purim to drink until one can no

longer distinguish between "Cursed is Haman" and "Blessed is Mordechai." The Talmud continues, relating how Rabbah ben Nachmani and R. Zeira became very drunk on Purim and that Rabbah cut R. Zeira's throat. The next day, Rabbah prayed on R. Zeira's behalf and brought him back to life. A year later, Rabbah asked, "Would you like to celebrate Purim with me again this year?" R. Zeira replied, "One cannot count on a miracle every time." Some rabbis take the story literally to emphasize the dangers of excessive drinking, while others say one should fulfill the obligation to get drunk and not fear negative consequences. Rabbi Jacob Emden (1697–1776) claims Rabbah pretended to kill R. Zeira to restore solemnity to drunken merrymaking. Maimonides writes that one "should eat meat and arrange a meal according to his means, and drink wine until he becomes inebriated and falls asleep," at which point he will not be able to make distinctions, thus fulfilling the Talmud's obligation. According to a midrash, in the days of the Messiah, when all the holidays and festivals will be forgotten, Purim will still be celebrated.

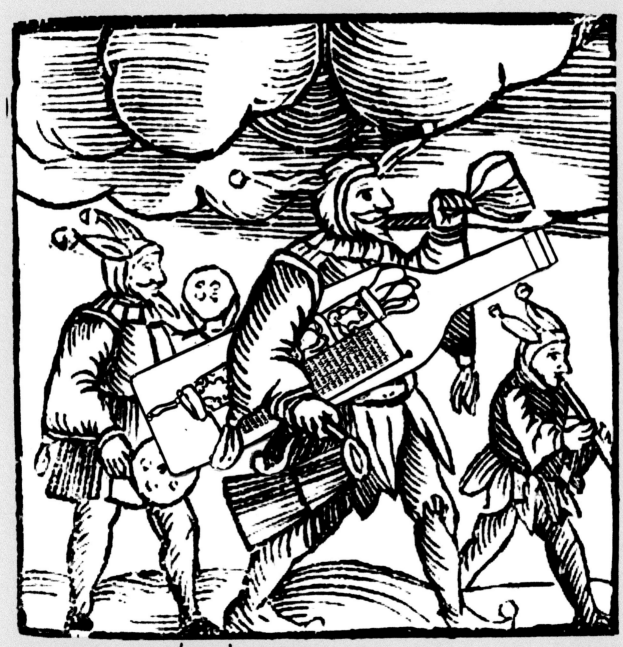

Shabbat Parah

Shabbat Parah, the "Shabbat of the Red Heifer," is the third of four special Shabbats during the month or so before Passover. Shabbat Parah's special Torah reading, Numbers: 19:1–22, describes a ceremony of purification which uses the ashes of a red heifer. The public reading of portion *Parah* before Passover was a reminder to those who had become impure to be purified before making the Passover pilgrimage to Jerusalem. The ritual, commanded to be "for all time," purifies those who have been defiled by contact with a human corpse. According to Jewish teaching, although the body of a deceased person is to be treated with the greatest care, it is ritually unclean. The heifer used in the ceremony had to be a completely red young cow with no blemishes and which never had borne a burden. After being ritually slaughtered, the red heifer was burned in its entirety outside the camp, and, in the days of the Temple, on the Mount of Olives. Cedar wood, hyssop, and wool dyed scarlet were added to the fire, and the ashes were placed in a vessel containing spring water. The ash-water was sprinkled on the ritually unclean on the third and seventh days after defilement. The priest who performed the rites became unclean until evening, and had to wash himself and his clothes in running water. According to the rabbis, only nine red heifers were slaughtered from the time of Moses to the destruction of the Second Temple, but each yielded enough ash to be stored for the future. Jewish tradition says that the Messiah will prepare the tenth and last red heifer. A midrash relates that even King Solomon, the wisest of men, was baffled by the paradox that the ashes of the red heifer "purified the defiled and defiled the pure." The ritual is considered a prime example of a *ḥok*, a biblical commandment that must be observed though there is no apparent logic. Nonetheless, numerous commentaries attempt to find some rationale for the ritual. An early midrashic tradition views the red heifer as an atoning rite for the sin committed by the Israelites in worshipping the Golden Calf. Another midrash teaches that God revealed the logic of the ritual of the red heifer to Moses but that he kept this knowledge secret.

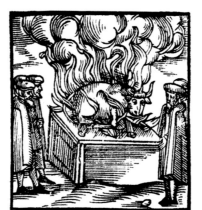

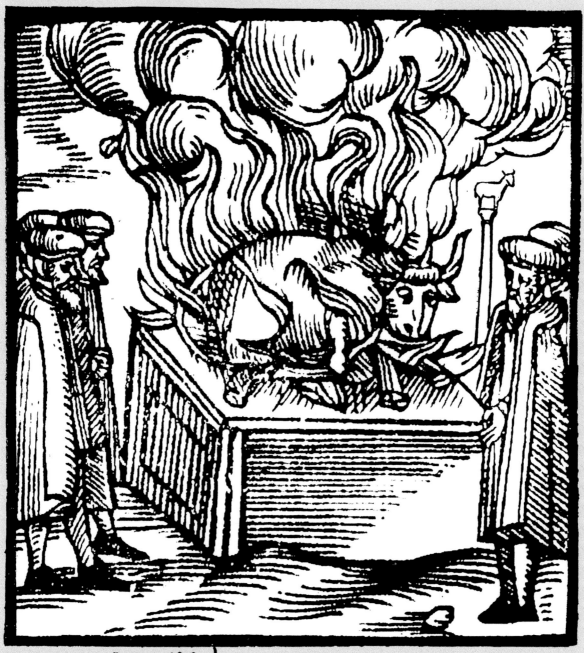

Bringing Wheat to be Ground into Flour for Passover

The Torah prohibits the eating of leavened bread during the festival of Passover, which is also called "The Feast of Unleavened Bread" (Exodus 13:3). When the Children of Israel left Egypt, there was not enough time to allow their bread to rise before going into the desert. The Passover Haggadah (liturgical rite) states, "In every generation one is obligated to view himself as though he came out of Egypt." To personally identify with coming out of Egypt, Jews refrain from eating any type of leavened bread during Passover. Unleavened bread, matzah, traditionally takes the place of *chametz* (leaven) during the holiday. The Hebrew word *chametz* refers to food prepared from any of five species of grain—wheat, barley, oats, spelt, and rye—which has been allowed to rise. Alongside these foods, Jews of Ashkenazi heritage add rice, millet, corn, and legumes, collectively known as *kitniyot*. Matzah can be made from any of these aforementioned five species of grain. However, it is customary to make matzah from wheat flour only; and it is essential that the wheat flour be given no chance to rise. Therefore, the grain used for matzah must be kept perfectly dry. The Torah commands, "And you shall observe the

unleavened bread" (Exodus 12:17). All wheat flour used in Passover matzah production must be continually inspected against any signs of moisture. Flour mill bins and transportation must be koshered for Passover, and any equipment used for *chametz* which cannot be thoroughly cleaned must be effectively kept apart. Kosher supervision of Passover flour for "regular" matzah begins prior to its milling. *Shmurah matzah*—"watched" or "guarded" matzah, preferred in some Orthodox Jewish communities—is made from wheat that is guarded from contamination by leaven from the time of the summer harvest to its baking into matzah five to ten months later. In order to ensure an appetite for matzah during Passover, a tradition discourages eating matzah during the thirty days prior to the festival. A Passover fund intended to provide the poor with matzah is known as *ma'ot chitim*, "the wheat fund," or *kimcha d'pischa*, "Passover flour." The collection of *ma'ot chitim* begins thirty days prior to Passover. The ancient practice of Jewish communities collecting money to help the local poor cover the cost of matzah is mentioned in the Jerusalem Talmud.

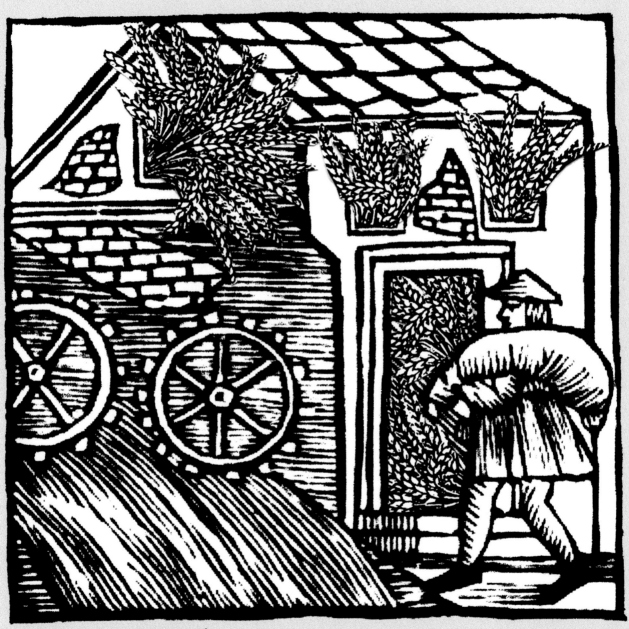

Baking Matzah

Matzah at the seder on the first night of Passover represents the unleavened bread that the Children of Israel ate in their haste to leave Egypt. In the Bible and Talmud, matzah is referred to as *lechem oni* (poor man's bread), since it is made from only two ingredients, water and flour. Another type of matzah is *matzah ashirah* (enriched matzah), so called because instead of water it is made with oil, milk, or eggs. Whereas the Torah prohibits eating *chametz* or having it in one's possession during all of Passover, the commandment for Jews to eat matzah applies only to the first night of the festival, or first two nights outside the land of Israel. For the remainder of the festival one may eat matzah but is not required to do so. *Matzah ashirah* is prohibited on the first night of Passover, although it may be eaten on the other days of the festival. However, some Sephardic communities allow matzah containing eggs to be eaten throughout the holiday. From the time the wheat is harvested until the matzah is removed from the oven, each step in the process must be performed for the purpose of having matzah on Passover. If the matzah was baked for any other purpose and later decided to be used at the seder, it would not have fulfilled the requirement for the holiday. Water used in matzah baking must

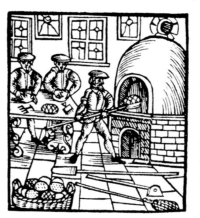

be left to stand overnight to ensure that it is allowed to cool, since water that is above room temperature can accelerate fermentation. This water is referred to as *"mayim shelanu"* ("our water"/water that has "slept"). Fermentation can also be delayed by the continual manipulation of the dough. Maimonides rules that as long as the dough is beaten, even if beaten all day long, it will never become *chametz*. Nevertheless, care is taken that the whole process, from kneading to baking, takes no longer than eighteen minutes. The Talmud reports a debate between the students of the sages Shammai and Hillel concerning whether one can bake Passover matzah that is up to a handbreadth in thickness. Jewish law follows the school of Hillel, which allows the thicker matzah. However, halakhic authorities agree that a thickness of a handbreadth or more is not acceptable. By the seventeenth century, the widespread custom was to make matzah thinner than the handbreadth mentioned in the Talmud. There is an obligation that every batch of matzah prepared is preceded by the baker's declaration, *"le-shem matzat mitzvah,"* that it is being baked to provide matzah for all who would taste freedom in the fulfillment of the divine command.

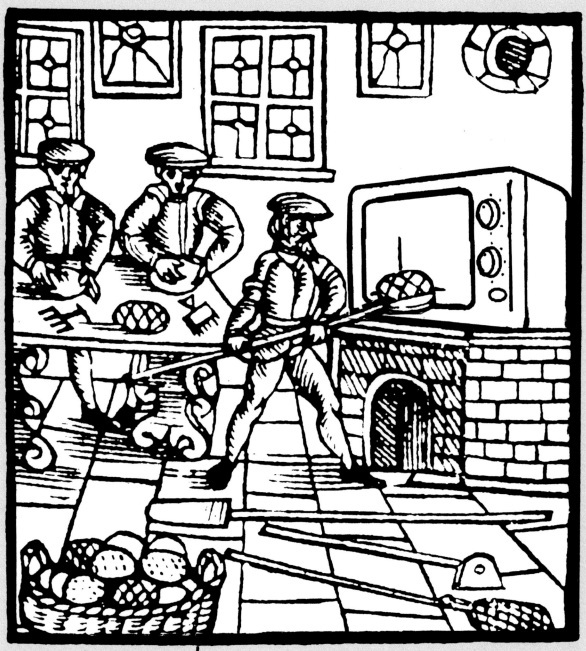

Kashering for Passover

According to Jewish law, pots, dishes, and utensils that are used year-round absorb *chametz* (leaven) and therefore may not be used during Passover. To be used for Passover, they must go through a process known as kashering (i.e., making ritually appropriate for use). Kashering for Passover is a complex process and it is important to note that not every material can be kashered. China, pottery, earthenware, cement, concrete, and enamel-coated pots cannot be kashered. The Ashkenazi custom is also not to kasher glass or crystal. Some authorities do not permit kashering plastic or other synthetic materials. Rusted or badly worn or chipped utensils also cannot be kashered. The Torah instructs that the proper kashering method to rid a vessel of *chametz* depends on the original method of food preparation through which *chametz* was absorbed into the vessel. There are four basic methods of kashering: burning (*libun*), boiling (*hagalah*), pouring boiled water (*eruy roschim*), and soaking (*milui v'eruy*). Kashering should begin at least two days before Passover, and is prohibited after midday

on the day before Passover. To kasher a *chametz* pot for the purpose of kashering utensils (as long as it is not enamel-coated or earthenware) the pot must be perfectly clean and not have been in contact with *chametz* in the previous twenty-four hours. The pot should be filled with water, the water brought to a boil, and a hot stone or hot piece of metal dropped in to make sure the water overflows. The hot water should then be poured out and the pot rinsed with cold water at which point the pot is kosher. The pot should be filled again, and the water brought to a boil. Utensils can now be immersed in the boiling water. The pot should be big enough to allow all surfaces of the utensil to be touched by the water, and each object should be placed in the pot in such a way that it will not touch the sides of the pot. Drinking glasses are kashered by soaking them in cold water for three periods of twenty-four hours. In many observant households, it is customary to have a special set of dishes, silverware, pots, pans, and other utensils that are used only during Passover.

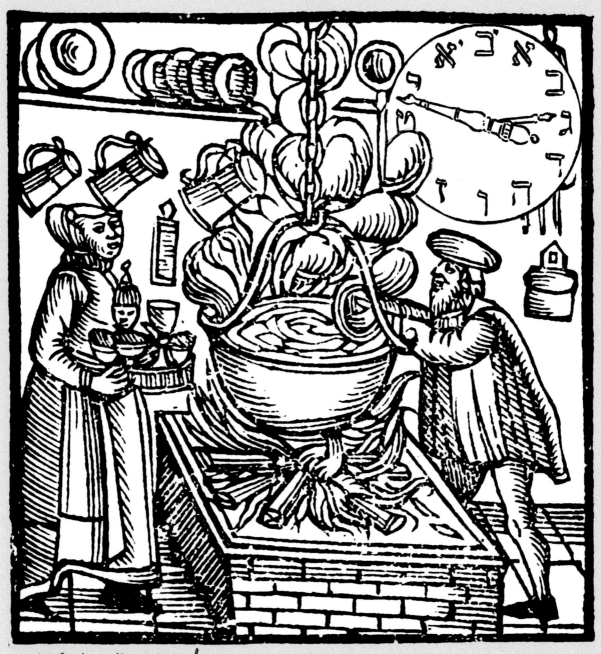

The Search for Leaven

Bedikat chametz is the ritual of searching for *chametz* (leaven) on the evening before Passover to ensure that during the holiday not even the smallest piece of *chametz* is left in the house. The Torah commands, "For seven days no leaven shall be found in your houses." In addition, the Torah asserts, "And no leaven shall be seen by you, nor shall any leaven be seen by you in all your borders for seven days" (Exodus 12:15–20). The two prohibitions are known as *bal yeraeh* and *bal yimatze*. The ceremony of *bedikat chametz* is preceded by the blessing, "Blessed are You, our God, Ruler of the world, who sanctifies us with commandments and calls upon us to remove *chametz*." Traditionally, a wooden spoon, a candle, a feather, and a bag are used for the search, during which it is customary not to speak. Since a blessing is not to be recited without a reason, lest God's name be taken in vain, a few pieces of bread are intentionally left around the house so ensure there will be leaven to remove. The kabbalists hid ten pieces of leaven for *bedikat chametz*. To the kabbalists leaven symbolized the ferment of base desires and evil impulses, which had to be purged. On the evening of its performance, *bedikat chametz* takes precedence even over Torah study. All areas of the house where *chametz* could possibly be found must be thoroughly searched. Once the search

has ended, the leaven collected is put away and the declaration is recited for the renouncement of all unfound *chametz* that is now "ownerless like the dust of the earth." On the fourteenth of Nisan, no later than ten in the morning, the leaven is burned. However, large amounts of *chametz* may be sold, a practice which goes back to the second or third century. An early rabbinic source records that a Jew on a boat may sell or give his *chametz* to a non-Jewish shipmate and buy it back after Passover. During the thirty days before Passover, one should be especially careful where one eats so that any remaining leaven will not be difficult to remove. Therefore, one should be careful with books that are read while eating, and shake out any leaven that may have fallen between the pages. It is the custom during Passover among some Hasidic Jews to not eat matzah that has become wet, including matzah balls, even though it cannot become *chametz*.

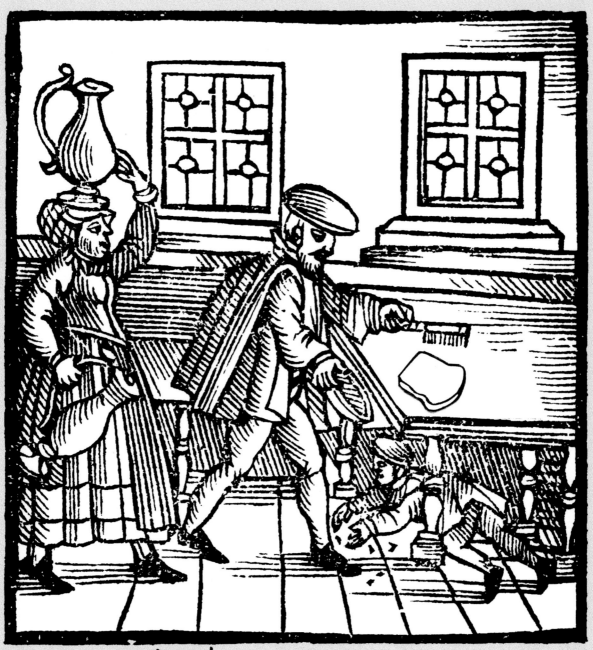

Lag Ba'Omer

Beginning on the second night of Passover, Jews observe the ritual of *Sefirat HaOmer* (Counting the Omer), based on the Torah's commandment to mark the time between the barley and wheat harvests (Deuteronomy 16:9). Omer means "barley sheaf" and refers to the offering brought to the Temple for forty-nine days leading to Shavuot. The grain was ground and sifted and then "waved" by the priest in a ceremony interpreted as a prayer to protect the harvest. Today the counting of forty-nine days symbolically recalls the time between the Exodus and receiving the Torah on Mount Sinai. The holiday of Lag Ba'Omer falls on the thirty-third day of the counting. "Lag" is made up of the Hebrew letters *lamed* and *gimel*, which have the numerical value of thirty and three. Traditionally, the days of the Omer are a time of semi-mourning in memory of Rabbi Akiva's 24,000 students, whom the Talmud says died in a plague. The thirty-third day is celebrated as the end of the plague, although the Talmud suggests students continued to die until Shavuot. The earliest mention of Lag Ba'Omer is in the Jewish legal text *Machzor Vitri* (1175), which notes it falls on the same day of the week as Purim.

The first mention of Lag Ba'Omer as presently observed is from the Talmudist Menachem Meiri (1300's), who notes a tradition from earlier authorities that Akiva's students stopped dying that day. Because the plague has ended, on Lag Ba'Omer mourning ceases, and weddings are permitted. An anonymous collection of customs, *Sefer Minhag Tov* (1273, Italy), describes the Omer period's prohibition of marriages and hair cutting as remembrances mourning the martyrs of the Crusades. Lag Ba'Omer is also the commemoration of the death of the second-century-CE Rabbi Shimon bar Yochai, the eminent Torah scholar to whom the *Zohar*, the great book of Jewish mysticism, was traditionally, but incorrectly, attributed. On the day of his death, Shimon Bar Yochai told his followers, "Now it is my desire to reveal secrets... The day will not go to its place like any other..." It is said daylight was miraculously extended until Rabbi Shimon completed his teaching and died. According to Rabbi Shimon's wishes, his *yahrzeit* was to be celebrated as opposed to merely observed. Thus arose the custom of lighting bonfires to symbolize the spiritual light he gave the world.

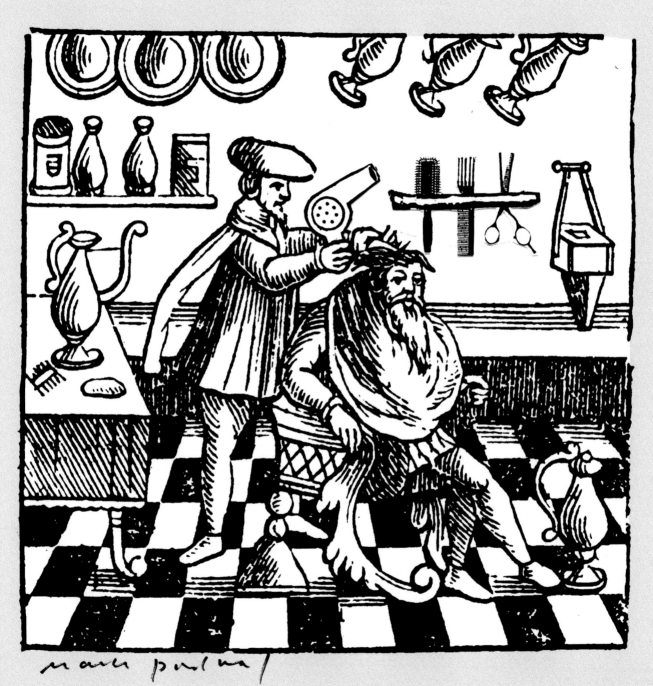

Shavuot

The Festival of Shavuot falls on the sixth day of the Hebrew month of Sivan. The festival's name, Shavuot, which means "weeks," denotes that the festival occurs exactly seven weeks after Passover (Exodus 34:22). Shavuot was originally an agricultural festival marking the beginning of the wheat harvest. During the Temple period, the first fruits of the harvest were brought to the Temple, and two loaves of bread made from the new wheat were offered to God. In post-Temple times, the festival became the anniversary of the giving of the Torah on Mount Sinai. On Shavuot, it is the custom, based in Jewish mysticism, to remain awake the entire night to study the Torah, a practice called *Tikkun Leil Shavuot*. During the morning service, the liturgical poem *akdamut* by Meir bar Yitzchak of Orléans (d. c. 1095) is recited. It describes Israel's loyalty to the covenant despite persecutions, and concludes with a detailed portrayal of the messianic era. Alternatively, it is a custom among many Sephardim to read the kabbalistic poem *Ketubah* (marriage certificate) *of God and Israel*. The most famous example of this poem is by Israel Najara

(c.1550–c.1625). After the Torah reading recounting God's revelation at Sinai, it is the custom to pass the Torah from person to person to recall the acceptance of the covenant. Isaac Tyrnau's *Sefer HaMinhagim* (1566) is the earliest source to mention eating dairy as a Shavuot tradition, although he provides no reason for the practice. A common explanation is that when the Children of Israel returned from Mount Sinai they were required to slaughter the animals and kosher their utensils according to all the newly received commandments. Since the revelation occurred on Shabbat, when slaughtering and cooking were prohibited, they ate dairy foods instead. A Shavuot custom dating back to approximately the eighth century is the reading of the biblical Book of Ruth. Among the explanations as to why this book is read on Shavuot is that Ruth took upon herself obedience to the Torah as Israel did at Sinai. Some add it is read because it is a story set in harvest-time. According to tradition, the desert of Sinai bloomed miraculously in anticipation of the revelation, and today synagogues are adorned with summer flowers.

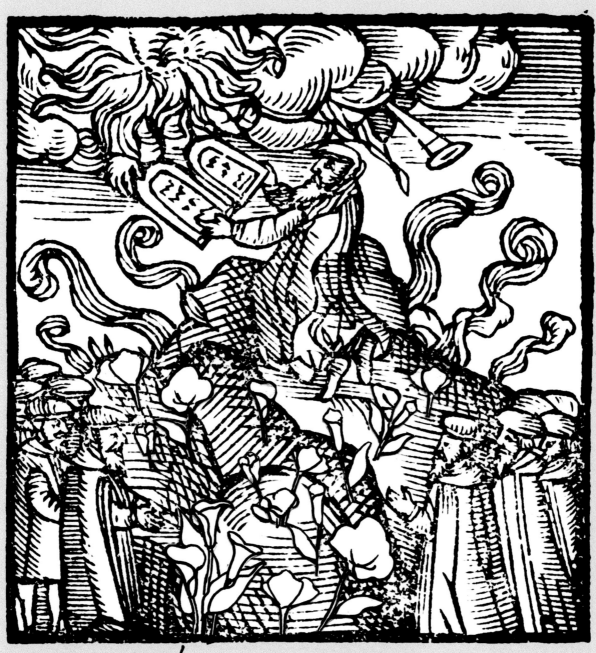

Tishah B'Av

The fast day of Tishah B'Av (the ninth day of the Hebrew month of Av) commemorates the destruction of the two Temples in Jerusalem. It has also come to memorialize other tragedies for the Jewish people. These include the massacres of Rhineland communities during the First Crusade and the expulsion of the Jews from Spain in the fifteenth century. Tishah B'Av culminates a three-week mourning period beginning on the seventeenth of Tammuz, which marks the breach of Jerusalem's walls by the Romans before the destruction of the Second Temple in 70 CE. During this period, weddings and other celebrations are prohibited and many do not cut their hair. From the first to the ninth of Av, abstention from eating meat or drinking wine, except on Shabbat, is customary. Traditionally, a small pre-fast meal consists of only bread, water, and a hard-boiled egg dipped in ashes. Many restrictions on Tishah B'Av are similar to those on Yom Kippur, including fasting, refraining from bathing, shaving, or wearing cosmetics, wearing leather shoes, and having sexual relations. Work is permitted but discouraged. The Torah is not studied other than verses relevant to the day. Many other traditional mourning practices are also observed, such as refraining from greeting people, smiling, laughing, and sending gifts. In the synagogue, the curtain is removed from the ark and the lights are dimmed. Some drape the ark in black. The Book of Lamentations is read and mourning prayers are recited. Prayer shawls and *tefillin* are not worn during the morning services. The morning Torah reading is from Deuteronomy 4:25–40, which warns of the destruction of the nation if it strays from the commandments. The haftarah is from Jeremiah 8:13–9:23. Old prayer books and Torah scrolls unfit for liturgical use are often buried on this day. According to Rabbi Moses Isserles (16th c.), it is customary to sit on low stools or on the floor, as during shivah (mourning period for someone deceased), from the pre-fast meal until midday. According to a midrash, the Messiah will be born on Tishah B'Av, thus causing this day of mourning to eventually become a day of rejoicing.

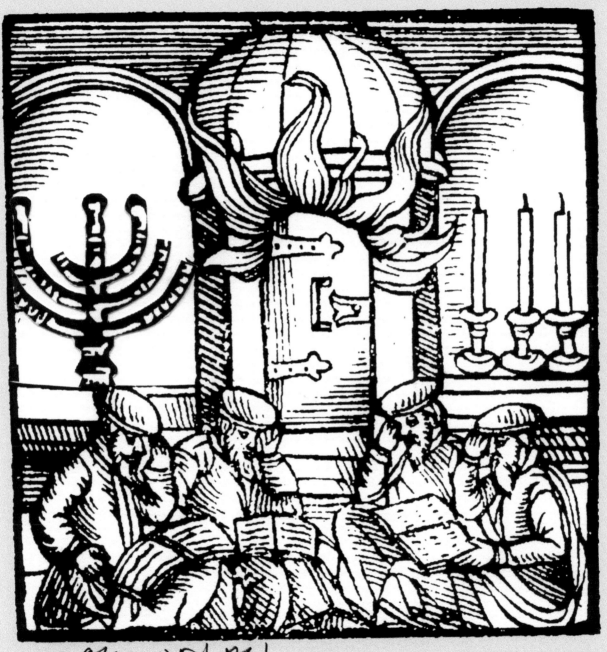

Blessing the New Moon

Rosh Hodesh (head of the month) is a minor holiday that marks the beginning of every Hebrew month. The Torah instructs that on Rosh Hodesh the people are commanded to be joyous, offer sacrifices, and recall God's divinity (Numbers 10:10). In antiquity there was no set calendar and the rabbinic court would declare a new month after receiving the testimony of two reliable witnesses that they had seen the new moon. Rosh Hodesh celebrations begin the Shabbat before the new moon with a special prayer at the conclusion of the Torah reading that expresses the hopes for the coming month. Rosh Hodesh has long been considered a special holiday for women, who are encouraged to abstain from work as a reward for not offering their jewelry for the fashioning of the Golden Calf (Exodus 32:2). According to Rabbi Akiva, God, with His divine finger, showed Moses the correct stage of the new moon to bless. *Kiddush levana* (sanctification of the moon) is a ritual performed when the moon is visible and not totally covered by clouds, in which prayers are recited to bless the new moon and thank God for its reappearance. In the month of Av, the blessing is traditionally postponed until after Tishah B'Av since

the beginning of the month is a time of mourning for the Temple's destruction and the prayer should be said in a spirit of joy. It is also not recited in Tishri before Yom Kippur night or on Friday night or the eve of any festival. In sixteenth-century Safed, kabbalists interpreted the moon's disappearance at the end of the month as the exile of the *Shekhinah* (Divine Presence). Hence, they initiated the custom of fasting on the eve of the new moon as a way of repenting and seeking God's return. It is still customary to stand on the tips of the toes three times, addressing the moon, "As I dance toward thee, but cannot touch thee, so shall none of my evil-inclined enemies be able to touch me." Those assembled at *Kiddush levana* greet each other saying three times, "Peace be to you." Some believe that one who recites the blessing of the new moon will not die that month. Since the prayers are said facing the moon, it may erroneously appear that the moon is being worshipped. Singing the prayer *Aleinu*, which states "It is our duty to praise [God]," at the service's conclusion affirms that God is worshipped and not the moon.

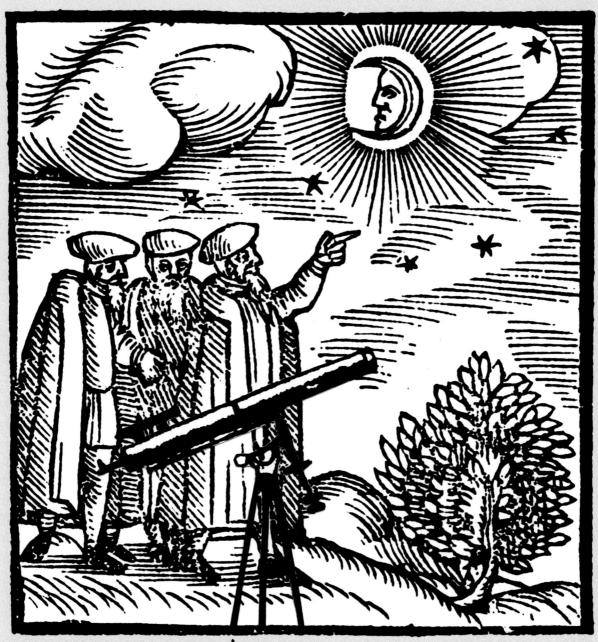

mark podwal

Blessing the Shabbat Lights

The two candles lit on Shabbat eve symbolize the biblical commandments, *zakhor v'shamor*, "remember" and "observe" the Shabbat (Exodus 20:8; Deuteronomy 5:12). It is customary to light two single-wick white candles, although any candles can be used as long as they burn for two to three hours. Some light one candle for each family member. Once lit, the candles should not be moved until after Shabbat. Rashi teaches that Shabbat candles should be lit where the Shabbat meal is eaten. Candles must be lit before Shabbat's official starting time, which varies from place to place and according to the time of year; but is generally eighteen minutes before sunset. According to the sages, if a poor person has to choose between lighting the Shabbat lamps and consecrating the Shabbat over wine, the former takes precedence. According to the kabbalists, the lighting of Shabbat candles is a special moment when petitions are answered in heaven. Thus arose the tradition of women reciting personal prayers when lighting Shabbat candles. However, the 1593 *minhagim* book states, "the woman thus atones for the sin of Eve in extinguishing the light of the world

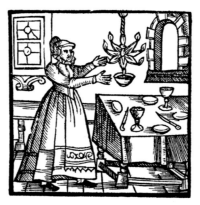

by corrupting Adam." When a mitzvah is performed requiring a blessing, first the blessing is recited and then the act performed. However, kindling the Shabbat candles follows a different practice. Since the blessing marks the beginning of Shabbat and lighting a fire on Shabbat is prohibited, first the candles are lit and then the blessing is recited. The explanation for the custom of a woman covering her eyes when saying the blessing is that when the candles are not seen, it is as if the candles had not been lit. When the blessing is completed and Shabbat has begun, the candles are then visible as lit. Many Sephardic Jews overlook these concerns and first recite the blessing and afterwards light the candles. According to a well-known Talmudic legend, two angels, one "good" and one "evil," accompany a person home from synagogue on Friday night. If the home is well prepared for Shabbat, the candles lit and the table set, the "good" angel says, "So may it be for next Shabbat also!" and the "evil" angel must respond, "Amen!" If the home is not prepared for Shabbat, the "evil" angel responds, "So may it be for next Shabbat also!" and the "good" angel must respond, "Amen."

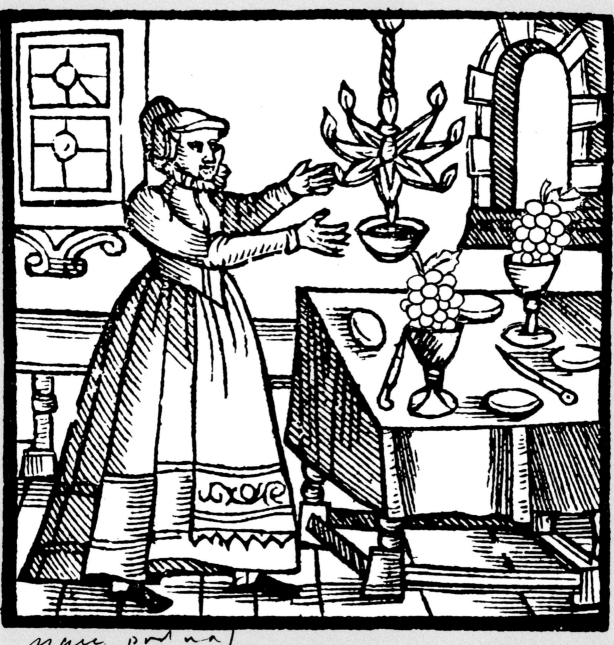

47

Havdalah

Havdalah, Hebrew for "separation," is the ceremony performed at the conclusion of Shabbat and festivals marking the passage from the sacred to the everyday. Blessings are recited over a cup of wine, a lit braided candle, and spices. The blessings refer to the distinctions between the holy and the ordinary, between light and darkness, between the people Israel and the other peoples of the earth, and between the seventh day of rest and the six days of work. It is customary to fill the wine cup until it overflows, symbolizing the hope that the coming week will be filled with joy and blessings. The *havdalah* candle must have multiple wicks, or be fashioned from multiple candles' wicks joined together, because the blessing itself is in the plural, "Who creates the lights of fire." The custom to look at the fingernails in the light of the *havdalah* candle is based on the Mishnah, which says one may only recite a blessing over a *havdalah* flame if there is benefit from the light of the flame. By using the light to distinguish between fingernails and the surrounding skin, the light is being used. Medieval kabbalists taught that when the *havdalah* candle shines on the fingernails, they become ten lights calling to mind the ten *sefirot*, the ten attributes of God. According to the Talmud, Rabbi Shimon

ben Lakish said, "On the eve of Shabbat, God gives man an additional soul, the *neshamah yetera*, and at the close of Shabbat He withdraws it from him." An explanation for the use of spices at the *havdalah* service is that with the departure of the additional soul, it is necessary to strengthen the faint remaining soul, as if with smelling-salts. Containers for the spices have been fashioned from a wide assortment of forms. Among the most popular, deriving from the Middle Ages, is a box in the shape of a fortified tower. At the conclusion of *havdalah*, the leftover wine is poured into a small dish and the candle is extinguished in it, signifying that the candle was lit solely for the commandment of *havdalah*. Based on Psalms 19:9, "the commandment of the Lord is clear, enlightening the eyes," some Jews dip a finger into the leftover wine and then touch their eyes. Maimonides holds that *havdalah* comes from the Torah's commandment to "Remember the Sabbath day, keep it holy" (Exodus 20:7). Others disagree, including the *Tosafot* (medieval commentaries on the Talmud), saying *havdalah* is *d'rabbanan*, a rabbinic decree. Whereas Shabbat officially ends after the appearance of three stars in the sky, some ignore the stars and like to delay *havdalah* later into the night in order to prolong celebrating Shabbat.

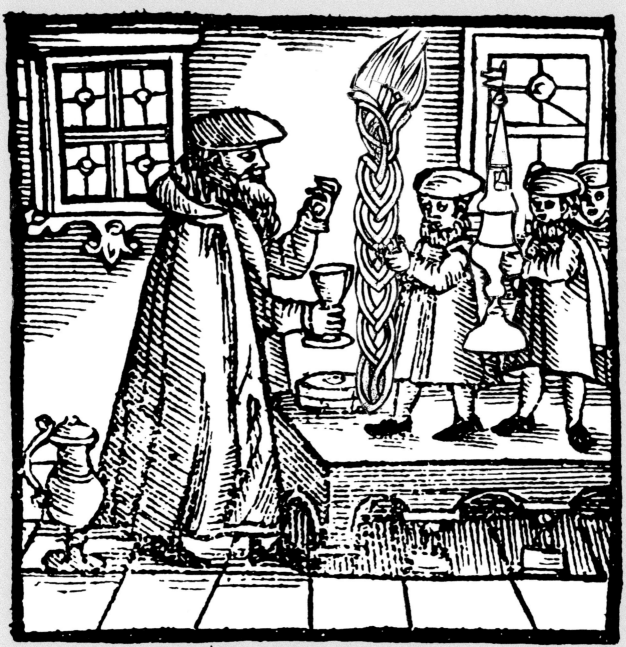

Circumcision

B'rit milah (circumcision) is among the earliest Jewish religious rituals. The Torah tells how Abraham was commanded by God to circumcise himself, all the males in his household, his descendants, and slaves, in an everlasting covenant (Genesis 17:9–13). Such is its importance that circumcision can be performed on Shabbat or a holy day. B'rit milah customs include the Shalom Zakhar, a festive meal the Friday night before the brit, having a minyan present, and, ever since the Middle Ages, inviting the prophet Elijah to be seated to the right hand of the sandak, the person who holds the infant. According to tradition, when circumcision in the Northern Kingdom was about to be abolished, the prophet Elijah is said to have fled to a cave and complained to God that Israel had forsaken the Lord's covenant, whereupon God ordained that no circumcision should take place except in the presence of Elijah. Elijah, who testified that Israel had abandoned the covenant, would testify forever that they are keeping it. A tale is told that Rabbi Judah the Pious

of Regensburg (1150–1270) when once serving as a sandak, said, "I do not see Elijah seated at my side." Elijah had refused to attend because the child would one day abandon the faith of his ancestors. According to a midrash, God said to Abraham, "because of the merit of circumcision your descendants will be saved from Gehinnom (hell), for only the uncircumcised will descend there." The belief that the uncircumcised would have no "share in the world to come" was frequently cited in medieval writings. Thus arose the custom at the grave to circumcise infants who died before their eighth day and to give them a name. A book on the laws and customs of circumcision by R. Jacob ha-Gozer (circa 1230) is the only source regarding a custom in which a mohel (ritual circumciser) cleans himself of the blood of circumcision. The cloth is then spread over the synagogue entrance to publicize the commandment of b'rit milah. Undoubtedly due to the rise of blood libels in the thirteenth century, the custom ceased.

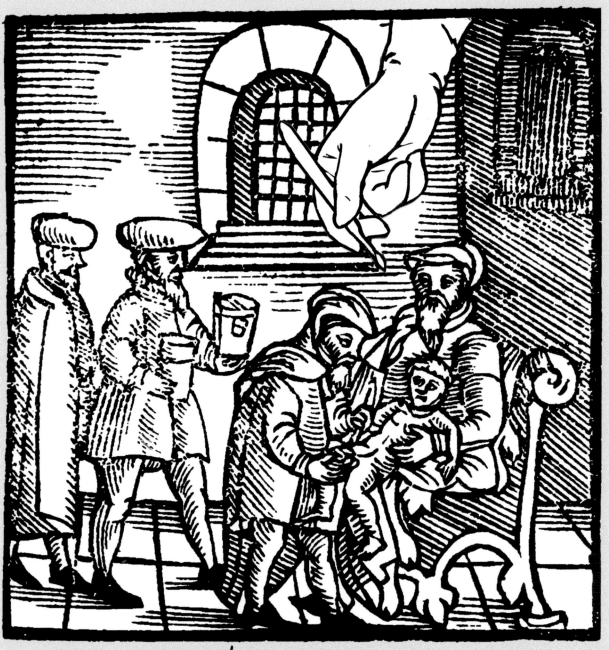

Wedding

The origins of the *chuppah*—the fabric canopy under which a Jewish wedding takes place—are rather ambiguous. The *chuppah* is often understood as symbolizing the home the new married couple will create together. Occasionally, a prayer shawl is used as a *chuppah* to signify that the couple will live under a Jewish roof. The word *chuppah* appears in the Bible to describe a room belonging to the groom (Psalms 19:6). In Talmudic times the word referred to the room wherein the marriage was consummated. The customarily used four-poled open canopy design for wedding ceremonies had its origins in the Middle Ages. Open on all sides, the *chuppah* has come to represent hospitality to guests, just as the patriarch Abraham's tent was open to welcome strangers. Traditionally, there should be open sky above the *chuppah*. A *chuppah* under the stars alludes to God's promise to "multiply your seed as the stars of heaven" (Exodus 32:13). It may also allude to God's blessing to Abraham, that his children shall be "as numerous as the stars of heaven" (Genesis 26:4). There was a custom that on the birth of a daughter parents would plant a cedar tree, on the birth of a

son a cypress, and years later the branches would be used for *chuppah* poles. Breaking a glass as part of the marriage ceremony—perhaps the most recognizable Jewish marriage practice—is discussed in the Talmud and has many explanations. Various reasons for the ritual have been offered. According to superstition, it was hoped the shattered glass fragments would harm demons that frequent celebrations or that the noise would frighten them away. A kabbalistic concept is that the Angels of Destruction wish to spoil this joyous event and breaking the glass satisfies their intent. Around the fourteenth century the custom came to be interpreted as a symbolic remembrance of the destruction of the Temple based on a verse from Psalm 137:6, "Jerusalem in memory even at the happiest hour." Other explanations include signifying the fragility of life and supplying a token of sadness, which should temper all rejoicings. By the fifteenth century, at the shattering of the glass it was customary to shout, "*Mazal tov!*" However, it should be noted that the *mazal tov* is not a response to the breaking of the glass, but marks the completion of the ceremony.

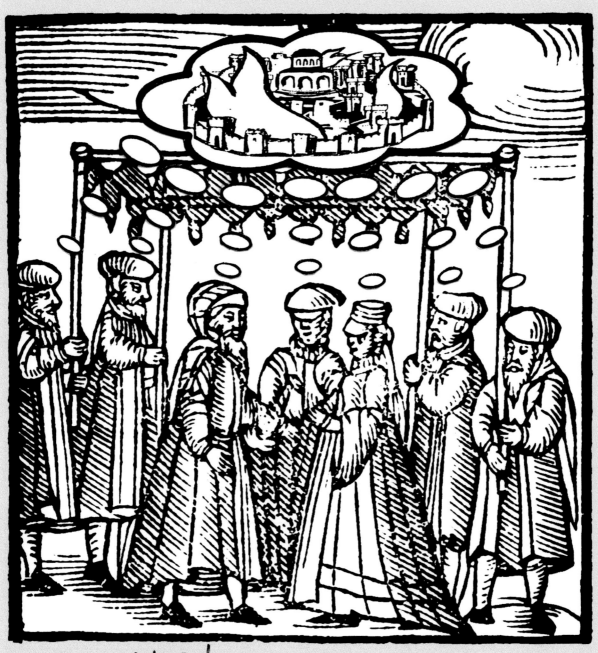

Carrying the Deceased to the Cemetery

To escort the deceased to burial was regarded as a foremost obligation in early rabbinic Judaism. To fail to do so was considered to be mocking God. Haste was made to bury the deceased, and even today effort is made for burial to take place within a day of the death. Many of the Jewish burial customs performed today originated in the Middle Ages, and reflect a fear of the supernatural. The *Zohar*, the primary work of medieval mysticism, offers two reasons why burial should be performed quickly.

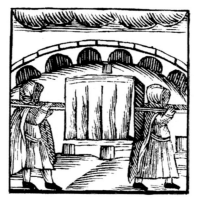

First, the soul, which dwelt in the body for so many years, is grief-stricken and this grief lasts as long as the body is not buried. Moreover, by not burying the body immediately we may be interfering with *gilgul* (reincarnation), God's plan to transfer that soul to another living body. A tradition to pour out all the water from jars and pitchers in the deceased's home was explained as a response to the Angel of Death, who, according to Talmudic legend, fulfills his task with a poison-tipped sword and might cleanse his sword in water near the dead, making the water unsafe to drink. At the conclusion of funeral rites, it is a custom to uproot some grass and earth and toss it over the right shoulder. Among the reasons offered for this tradition is that just as the torn grass will grow back, so will it be with the deceased; at the time of the Resurrection the dead will return to life. According to a midrash, the soul accompanies the body to the grave, and is unable to leave until it receives permission from the mourners. Throwing the grass and earth behind one is a sign that permission is granted, and repulses the demons that hover at one's back. The custom of washing one's hands after a funeral was thought to dispel the clinging demons of uncleanliness that would follow the mourner home. The Talmud notes fasting on the anniversary of a death, but not as a widely observed custom. Tyrnau, in his *Sefer HaMinhagim*, was the first to name this anniversary "*yahrzeit*" and to discuss its observance in detail.

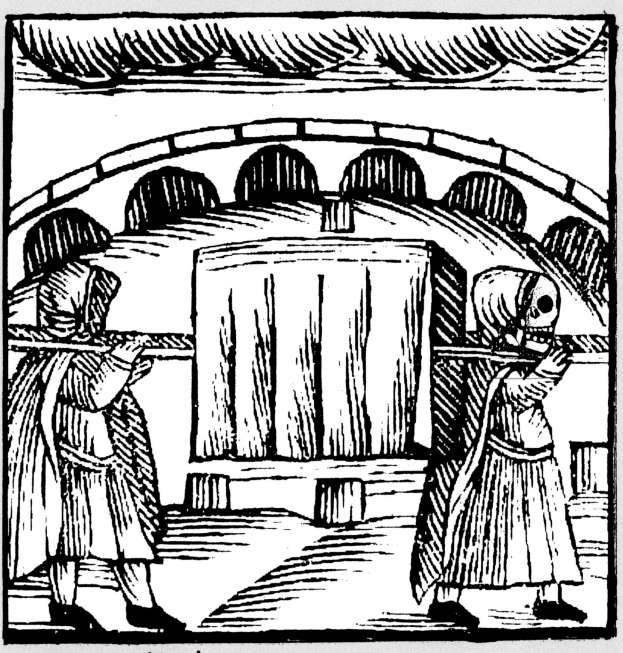

mach pascal

Rosh Hashanah

Blowing the shofar: Maimonides, *Mishneh Torah, Zemanim, Hilchot Shofar* 1:1; *Shulchan Arukh, Orach Chayim* 585:1; Mishnah Berurah 585:2.

Temple practice: Mishnah Rosh Hashanah 3:3.

The choice of a ram's horn: Mishnah Rosh Hashanah 3:2; Babylonian Talmud Rosh Hashanah 26a.

Midrash about Abraham: Tanchuma, Vayera.

Not sleeping: *Shulchan Arukh, Orach Chayim* 583:2; *Arukh HaShulchan, Orach Chayim* 597:2.

Taste of death: Babylonian Talmud Berakhot 57b.

Shabbat Shuvah

Parable: Pesiqta Rabbati 44

Landau quotation: Marc Saperstein. *"Your Voice Like a Ram's Horn": Themes and Texts in Traditional Jewish Preaching* (Cincinnati: HUC Press, 1996), 145.

Kapparot

Recitation: *Days of Awe: A Treasury of Jewish Wisdom for Reflection, Repentance, and Renewal on the High Holy Days*, ed. S.Y. Agnon (New York: Schocken Books, 1995), 148.

Selling the fowl: ibid., 149. Cf. *Shulchan Arukh, Orach Chayim* 605:1.

Duran: ibid. 149.

Planting sprouts: Commentary of Solomon ben Isaac (Rashi) to Babylonian Talmud Shabbat 81b.

Ushpizin

Rabbi Eliezer and Rabbi Akiva: Babylonian Talmud Sukkah 11b.

Accompanying the Messiah: *Zohar Hadash, Emor* 103b.

Sukkot

Direction for holding citron: *Shulchan Arukh, Orach Chayim* 648, 651:1.

Direction for holding lulav: Babylonian Talmud Sukkah 37b; *Shulchan Arukh, Orach Chayim* 650.

Hoshana Rabbah

Sealed in the book of life: *Zohar Hadash, Tsav* 31b.

Shadows and reflections: Joshua Trachtenberg, *Jewish Magic and Superstition* (New York: Behrman House, 1939), pp. 214–16.

Marching around the synagogue: Mishnah Sukkah 4:5; Babylonian Talmud Sukkah 45a; *Shulchan Arukh, Orach Chayim* 660:1.

Willow branch: *Shulchan Arukh, Orach Chayim* 664:4.

Simchat Torah

Circling the synagogue: *Shulchan Arukh, Orach Chayim* 669.

Satan and new Torah reading: *Tur, Orach Chayim* 699.

Hanukkah

Talmudic origins: Babylonian Talmud Shabbat 21b.

Books of Maccabees: 1 Maccabees 4:52–59, 2 Maccabees 10:1–8.

Josephus: *Jewish Antiquities* 12.7.7.

Maharal (Judah Loew): *Ner Mitzvah* (composed c. 1590–1600).

Pirsumei nissa and *la-shem mitzvah*: *Shulchan Arukh, Orach Chayim* 671:5; Babylonian Talmud Shabbat 21b.

Tu B'Shevat

New Year of Trees: Mishnah Rosh Hashanah 1:1.

Tithing fruit trees: Babylonian Talmud Rosh Hashanah 2a, 14a.

Prohibitions: *Shulchan Arukh, Orach Chayim* 131:6, 572:3.

Kabbalistic seder: *Hemdat Yamim* (1731) and *Pri Etz Hadar* (1728).

Midrash: Sifrei Devarim 203:10 (on

Deut. 20:19).

Yochanan ben Zakkai: *Avot of Rabbi Nathan* B 31.

Shabbat Shekalim

Four Portions: Mishnah Megillah 3:4.

Counting objects: Babylonian Talmud Berakhot 62b and Yoma 22b.

Paying same amount: Rashi, commentary to Exodus 30:12.

Midrash: Tanchuma, Ki Tisa.

Isserles: *Mappah to Shulchan Aruch, Orach Chayim,* 694:11.

Shabbat Zakhor

Biblical requirement to hear Zakhor read: Babylonian Talmud Megillah 18a, 30a.

Importance of hearing Zakhor read: *Shulchan Arukh, Orach Chayim* 685:7.

Midrash about Agag: Babylonian Talmud Megillah 13a.

Rashi: Commentary on Deut. 25:17. See also, Tanchuma, Ki Teizei 8.

Purim

Maimonides on reading Esther: *Mishneh Torah, Sefer Zemanim, Laws of Megillat Esther* 1:1.

Reading scroll like a letter: Maimonides, *Mishneh Torah, Sefer Zemanim, Laws of Megillat Esther* 2:12. *Shulchan Arukh, Orach Chayim* 690:17.

Listening to every word: Babylonian Talmud Arakhin 3a; Megillah 4a; *Shulkhan Arukh, Orach Chayim* 690:18.

Exchanging gifts, charitable gifts: Babylonian Talmud Megillah 7b; *Shulchan Arukh, Orach Chayim* 694, 695.

Drunkenness: Babylonian Talmud Megillah 7b; *Shulchan Arukh, Orach Chayim* 695:2.

Rabbah and Rabbi Zeira: Babylonian Talmud Megillah 7b.

Emden: *Hagahot Ya'avetz* to Megillah 7b.

Maimonides on food and drink: *Mishneh Torah, Sefer Zemanin, Laws of Megillat Esther,* 2:15.

Midrash: Midrash Proverbs 9:1.

Shabbat Parah

Purification before pilgrimage: Rashi, commentary on Babylonian Talmud, Megillah 29a.

Defilement by a corpse: Leviticus 21:1–3; Mishnah Kelim 1:1ff.; Ohalot 13:4–5.

Nine Red Heifers: Mishnah, Parah 3:5.

Last Red Heifer: Maimonides, *Mishneh Torah, Taharah, Red Heifer* 3:4.

Midrash about King Solomon: Ecclesiastes Rabbah 7:23:4.

Midrash about Golden Calf: Numbers Rabbah 19:8.

Midrash about Moses: Numbers Rabbah 19:6.

Bringing Wheat to be Ground into Flour for Passover

Every generation: cf. Mishnah Pesachim 10:5; Babylonian Talmud Pesachim 116b.

Five grains: Babylonian Talmud Menachot 70b, Pesachim 35a.

Ancient practice of collecting funds to provide matzah: Jerusalem Talmud Bava Batra 5:4/17b.

Baking Matzah

Lehem Oni: Deuteronomy 16:3; Babylonian Talmud Pesachim 36a, 115b.

Matzah Ashirah: Babylonian Talmud Pesachim 35a.

Commandment to eat matzah: Exodus 12:15; Deuteronomy 16:8; Sifre Deuteronomy 130b; Babylonian Talmud Pesachim 28b, 120b.

Delaying fermentation: Babylonian Talmud Pesachim 42a; *Shulchan Arukh, Orach Chayim* 453:4, 9; 455:1ff.

Time limit to make matzah: Babylonian Talmud Pesachim 46a; *Shulchan Arukh, Orach Chayim* 459:2; Maimonides, *Mishneh Torah, Zemanim, Laws of Leavened and Unleavened Bread* 5:13.

Thickness of matzah: Babylonian Talmud Pesachim 36b–37a; *Shulchan Arukh, Orach Chayim* 460:4–5.

Kashering for Passover

On the use of regular dishes etc.: Babylonian Talmud Avodah Zarah 76a, Pesachim 8b, 30a–30b.

Materials which cannot be kashered: *Kitzur Shulchan Arukh* 116:1–2.

Kashering based on type of material and its use: *Shulchan Arukh, Orach Chayim* 451:4ff.

The Search for Leaven

Search the evening before Passover: Mishnah Pesachim 1:1.

Blessing: Babylonian Talmud Pesachim 7b.

Performed while not speaking: *Shulchan Arukh, Orach Chayim* 431–32.

Kabbalist's attitudes: see Joel Hecker, "Leaven (in Judaism)" in *Encyclopedia of the Bible and Its Reception* (Berlin: De Gruyter, 2017), vol. 15, cols. 1180–82.

Recitation of renunciation: *Shulchan Arukh, Orach Chayim* 434:2.

Selling *hametz*: Tosefta Pesachim 2:6; *Shulchan Arukh, Orach Chayim* 448:3; Maimonides, *Mishneh Torah, Zemanim, Laws of Leavened and Unleavened Bread* 4:6.

Lag Ba'Omer

Bringing sheaves to the Temple: Leviticus 23:15–16; Deuteronomy 16:9–12; Babylonian Talmud Menachot 63b–64a, 65b; Rosh Hashanah 16a.

Death of Akiva's students: Babylonian Talmud Yevamot 62b; Genesis Rabbah 61:3.

Meiri on Geonic tradition: Gloss to Yevamot 62b.

Permission for marriages: *Shulchan Arukh, Orach Chayim* 493:1–3.

Prohibitions: *Sefer Minhag Tov* section 61.

Shimon bar Yochai's statement: Babylonian Talmud Shabbat 33b; *Zohar, Idra Zuta* 3:291b.

Shavuot

Harvest festival in the Bible: Exodus 23:16, 34:22; Leviticus 23:16–17; Numbers 28:26; Deuteronomy 16:10.

Celebration of the giving of the Torah: Babylonian Talmud Shabbat 86b–88a.

Tikkun Leil Shavuot: *Zohar Hadash, Emor* 3:98a.

Absence of kosher meat following revelation: Mishnah Berurah 494:12.

Eating dairy: *Shulchan Arukh, Orach Chayim* 494:3.

Reading Ruth: Soferim 14:16.

Summer flowers: *Shulchan Arukh, Orach Chayim* 494:3; Mishnah Berurah 494:10.

Tishah B'Av

Destruction of the Temples: Mishnah Ta'anit 4:6; Babylonian Talmud Ta'anit 29a.

Restrictions and prohibitions: Babylonian Talmud Ta'anit 30b; *Shulchan Arukh, Orach Chayim* 554:1ff., 558; *Kitzur Shulchan Arukh* 124:1ff.

Liturgical practice: *Shulchan Arukh, Orach Chayim* 559:1–2.

Prayer shawls: *Shulchan Arukh, Orach Chayim* 553:1.

Reading Deuteronomy: *Shulchan Arukh, Orach Chayim* 559:4.

Midrash: Lamentations Rabbah 1:51.

Blessing the New Moon

Rabbinic court and new moon: Mishnah Rosh Hashanah 1:6ff., 2:5ff.

Golden Calf: *Arukh HaShulchan, Orach Chayim* 417:10.

Rabbi Akiva: Maimonides, *Mishneh Torah, Zemanim, Sanctification of the New Month* 1:1.

Kiddush Levana: Babylonian Talmud Rosh Hashanah 20a, 25a; Sanhedrin 42a.

Delaying recital: Babylonian Talmud Sanhedrin 41b; *Shulchan Arukh, Orach Chayim* 426:1ff.

Kabbalistic practice: *Shulchan Arukh, Orach Chayim* 426:2.

Aleinu: *Ta'amei Haminhagim* 463.

Blessing the Shabbat Lights

Candles: *Shulchan Arukh, Orach Chayim* 263:1.

Not moving candles: *Shulchan Arukh, Orach Chayim* 263:14.

Rashi: Commentary on Shabbat 25b.

Precedence of lighting: Babylonian Talmud Shabbat 23b.

Practice for lighting: *Shulchan Arukh, Orach Chayim* 263:5.

Sephardic practice: Rav Ovadyah Yosef, *Sh"t Yechave Daat* 2:33.

Talmudic legend: Babylonian Talmud Shabbat 119b.

Havdalah

Candle, wine, and spices: Mishnah Berakhot 8:5; Babylonian Talmud Pesachim 103b.

Explanation for practices: Mishnah Berakhot 8:5; *Shulchan Arukh, Orach Chayim* 298:2.

Looking at fingernails: Mishnah Berakhot 8:6; Babylonian Talmud Berakhot 51b; Pirqei DeRabbi Eliezer 20:4–8.

Kabbalistic teaching: *Zohar Hadash, Bereshit* 1:21a.

Shimon ben Lakish: Babylonian Talmud Ta'anit 27b.

Maimonides: *Mishneh Torah, Zemanim, Shabbat* 29:1.

Disagreement: Mishnah Berurah 296:1.

Prolonging Shabbat: *Shulchan Arukh, Orach Chayim* 299:6.

Circumcision

Trumps Sabbath and Holy Days: Mishnah Shabbat 19, *Shulchan Arukh, Yoreh De'ah* 266:2.

Customs: Pirqei DeRabbi Eliezer 29:17–18; *Shulchan Arukh, Yoreh De'ah* 265:11.

Elijah's role: 1 Kings 19:10ff; Song of Songs Rabbah 1:6.

Judah the Pious: *Ma'aseh-buch*, no. 180, 54d.

Abraham: Babylonian Talmud Eruvin 19a; Genesis Rabbah 48:8.

Jacob ha-Gozer: The "Principles of Circumcision" of R. Jacob ha-Gozer, in *Zikhron Berit la-Rishonim*, ed. Y. Glasberg (Berlin, 1892), p. 61.

Wedding

Chuppah symbolizing home: *Shulchan Arukh, Even HaEzer* 55:1.

Talmudic times: Jerusalem Talmud Sotah 9:16.

Open sky: *Mappah* to *Shulchan Arukh, Even HaEzer* 61:1.

Stars of heaven analogy: *Shulchan Arukh, Even HaEzer* 61:1.

Cypress and cedar trees: Babylonian Talmud Gittin 57a.

Breaking glass: Babylonian Talmud Berakhot 30b-31a.

As reminder of destruction of Jerusalem: Kolbo (Venice, 1547), Laws of Tishah B'Av, p. 67.

Tempering rejoicing: Babylonian Talmud Berakhot 30b-31a, *Shulchan Arukh, Even HaEzer* 65:3.

Carrying the Deceased to the Cemetery

Importance of escorting the deceased: Babylonian Talmud Berakhot 18a.

Grief-stricken soul: *Zohar Hadash, Vayehi* 1:218b-219a.

Gilgul: *Zohar Hadash, Emor*, 3:88b.

Angel of Death's arrow: Babylonian Talmud Avodah Zarah 20b; *Turei-Zahav, Yoreh De'ah* 339:4.

Throwing dirt over shoulder: *Kitzur Shulchan Arukh* 199:10.

Soul cannot depart without permission: Babylonian Talmud, Shabbat 152b; Genesis Rabbah 100:7.

Accompanying the mourner home: *Shulchan Arukh, Yoreh De'ah* 376:4.

Anniversary of death: Babylonian Talmud Nedarim 12a.

ACKNOWLEDGMENTS

I would like to express my gratitude to those who supported and worked on this publication as well as those involved with exhibiting the collages.

I am especially indebted to the Plotkin Foundation, which provided the funding for this book. For decades, the Foundation's Executive Director, Sandy Plotkin, has been extraordinarily generous in sponsoring my art projects.

Jason Kalman, Co-Director of Hebrew Union College Press, for his scholarship and enthusiasm.

Abby Schwartz, Director of the Cincinnati Skirball Museum, for a wonderfully engaging exhibition of my art.

Paul Neff, whose graceful design has enhanced this small volume.

Ariel Podwal for digitally refining the woodcut reproductions.

Scott-Martin Kosofsky, author of *The Book of Customs: A Complete Handbook for the Jewish Year*, for his advice on the images.

Sharon Lieberman Mintz, Curator of Jewish Art at the Library of The Jewish Theological Seminary, for providing a copy of the Lag Ba'Omer woodcut.

Francine Klagsbrun for her suggestions for the publication's introduction.

Zachary Levine, Director of Archival and Curatorial Affairs at the United States Holocaust Memorial Museum, for his early feedback.

Rabbi Joseph A. Skloot for introducing me to Jason Kalman.

Peter Lehrer for his recommendation that prompted this series of artworks.

Rachel Boertjens, Curator Bibliotheca Rosenthaliana, for exhibiting "A Collage of Customs" at the Allard Pierson Museum, University of Amsterdam.

And to all at **Hebrew Union College Press** whose comprehensive efforts, including citing sources, enriched this work.

Mark Podwal